D0005500

The American Wing

at The Metropolitan Museum of Art

A WALKING GUIDE

The Metropolitan Museum of Art, New York
In association with Scala Publishers

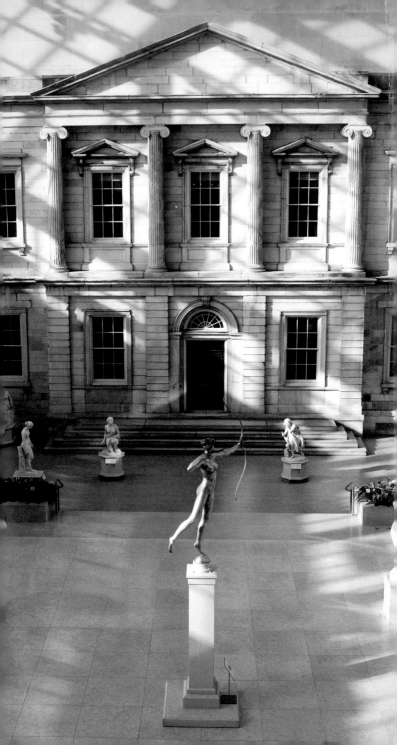

Introduction

Welcome to the American Wing, the Metropolitan Museum's principal display of American art made before 1920. Here, the emphasis is on artworks and objects from the 17th- and 18th-century colonial settlements on the East Coast of North America and in the United States as it expanded across the continent, up to the early 20th century. (Native American art is on view in the galleries of the Arts of Africa, Oceania, and the Americas; works from the later 20th and 21st centuries are in the galleries of Nineteenth-Century, Modern, and Contemporary Art.)

The American collections reflect the evolving interests of the Museum and its audiences since its founding in 1870. Among the Museum's early trustees were painters and sculptors who encouraged the acquisition of works by American artists of the time—hence the particularly rich holdings of landscape paintings by the Hudson River School and of marbles and bronzes by sculptors trained in Rome or Paris. Later trustees included collectors of the arts of the colonial period, who focused on acquiring historic interiors together with the appropriate decorative furnishings. In the decades since the Museum's centennial in 1970, the curatorial staff has expanded its reach into all aspects of the decorative arts of the later 19th and early 20th centuries.

The original American Wing, a three-story structure purpose-built in 1924 for the installation of colonial and early Federal-period interiors, was the gift of Robert W. and Emily J. de Forest. This first building was enveloped in a massive extension in 1980: to the south, a glass-roofed courtyard (The Charles Engelhard Court, 700–707); to the north and west, galleries for paintings and sculpture (The Joan Whitney Payson Galleries, 755–772) and for special exhibitions (The Erving and Joyce Wolf Gallery, 746), as well as space for the eventual installation of publicly accessible art storage (The Henry R. Luce Center for the Study of American Art, 773–774), 19th-century period rooms, and decorative arts galleries. Between 2007 and 2012, these two buildings were modernized and reconceived as the new American Wing, its collections displayed chronologically in the four broad areas that are the organizing principle of this pocket guide.

Emanuel Leutze, *Washington Crossing the Delaware*, 1851 (detail)

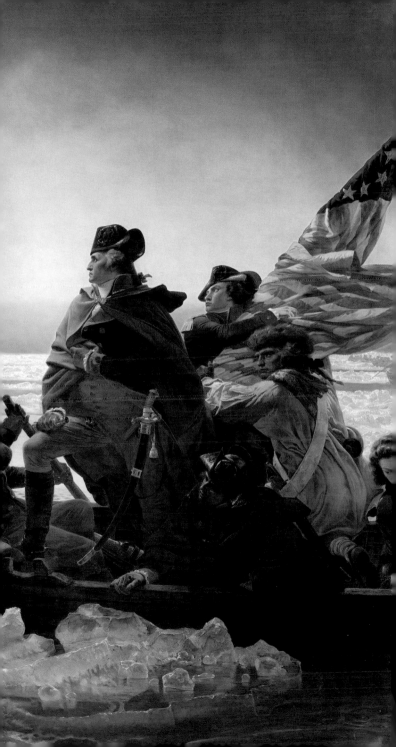

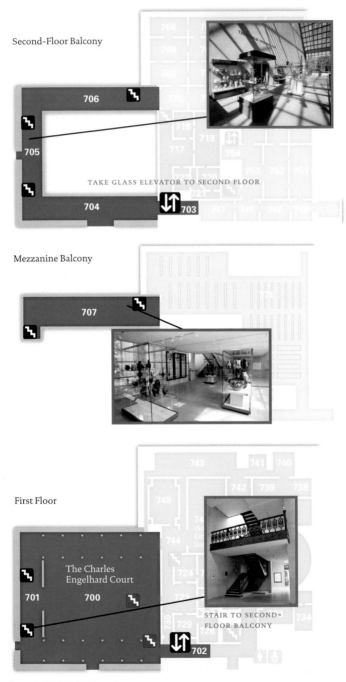

Second-Floor Balcony

706

705

TAKE GLASS ELEVATOR TO SECOND FLOOR

704

703

Mezzanine Balcony

707

First Floor

The Charles
Engelhard Court

701 700

STAIR TO SECOND-
FLOOR BALCONY

702

Architecture, Sculpture, and Decorative Arts

GALLERIES 700–707

The Charles Engelhard Court—a vast, light-filled atrium, designed by Kevin Roche John Dinkeloo and Associates in 1980 and modified by the architects in 2009—is the main entrance to the American Wing. It is dominated on the north side by Martin Thompson's monumental marble facade of the Branch Bank of the United States (1824), originally on Wall Street, and on the south side by Louis Comfort Tiffany's garden loggia with floral capitals (1905) from his Long Island country house. These two pieces of architecture represent New York's transition from provincial classicism to international aesthetic leadership.

Displayed within the court are works of monumental sculpture, stained glass, and a variety of decorative arts, including ceramics, glass, metalwork, and jewelry. Behind the loggia, cast-iron staircases by the Chicagoan Louis Sullivan lead to the second-floor galleries for painting, sculpture, and decorative arts. Opposite the loggia, bronze torchères by the New Yorker Richard Morris Hunt flank the stairs leading down to the bank facade, the Frank Lloyd Wright Room, and The Erving and Joyce Wolf Gallery for special exhibitions. To the west, a café overlooks Central Park.

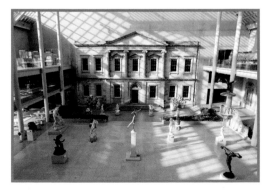

Neoclassical Marble Sculpture, 1845–70

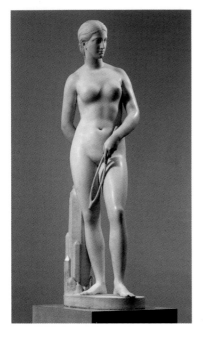

Hiram Powers, *California*,
1850–55; this carving, 1858

The marble sculptures installed directly in front of the facade of
the Branch Bank of the United States were created by a group
of mid-19th-century expatriates who practiced their art in
Italy. Based in Florence and Rome, these professional sculptors
enjoyed access to talented carvers, an abundant supply of
statuary marble, and the inspiration of classical, Renaissance, and
contemporary art. They modeled narrative subjects drawn from
mythology, literature, and history in a smooth, idealized style.
While Randolph Rogers's *Nydia, the Blind Flower Girl of Pompeii*
took its theme from the eruption of Mount Vesuvius in A.D. 79,
Hiram Powers's *California* was inspired by the recent California
Gold Rush, which had begun in 1848.

The Charles Engelhard Court

Beaux-Arts Bronze Sculpture, 1880–1920

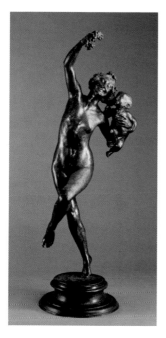

Frederick William MacMonnies,
Bacchante and Infant Faun,
1893–94; this cast, 1894

By the late 19th century, bronze had surpassed marble as the medium of choice for a generation of American sculptors trained in Parisian academies. These artists worked in a cosmopolitan Beaux-Arts style that emphasized mastery of the human form, expressive realism, and fluid surface modeling, and bronze was a material ideally suited to capturing every nuanced detail. Sculptors continued to select time-tested subjects; for instance, Frederick William MacMonnies drew on Greco-Roman mythology for his gleeful, spiraling *Bacchante and Infant Faun.* They also expanded their repertoire to include such contemporary themes as the European Gypsy, the American Indian, and wildlife.

Small-scale marble and bronze sculpture is on view in the second-floor galleries (755–772).

The Charles Engelhard Court

Augustus Saint-Gaudens

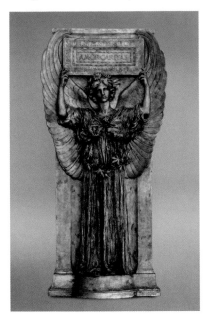

Augustus Saint-Gaudens,
Amor Caritas, 1880–98;
this cast, 1918

The sculptures by Augustus Saint-Gaudens (1848–1907) on view
in The Charles Engelhard Court are representative of the artist's
work on a monumental scale. The greatest American sculptor of
the late 19th century, Saint-Gaudens rendered his subjects in a
rich array of materials, including gilt bronze and colored marble,
and in a variety of compositional formats, from low to high relief
to sculpture in the round. Some works, including *Hiawatha*
and the Vanderbilt mantelpiece, were once installed in artfully
planned domestic interiors. Others, such as *Diana* and *Amor
Caritas*, were designed for public display. Three of the
sculptures—*The Children of Jacob H. Schiff*, *Diana*, and *Amor
Caritas*—were carved or cast specifically for the Metropolitan
in the early 20th century.

The Charles Engelhard Court

Opalescent Glass Windows, 1880–1925

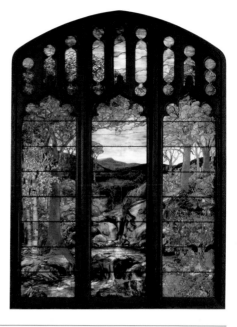

Louis C. Tiffany,
Autumn Landscape,
1923–24

The Charles Engelhard Court features an extraordinary
assemblage of opalescent glass windows dating from the 1880s
through the 1920s and designed by the two pioneers of the
medium, John La Farge and Louis Comfort Tiffany. The inven-
tion of opalescent glass around 1880 revolutionized an art form
that had been practiced since medieval times, opening up a range
of new possibilities defined by more varied textures, more
detailed modeling, and a richer palette. This important American
development enabled artists to create compositions that exploited
the inherent qualities of the glass. La Farge and Tiffany employed
diverse techniques to maximize the range of effects, resulting
in innovations such as confetti glass, achieved by embedding
tiny pieces of colored glass in molten glass; drapery glass, made
by manipulating the hot glass into folds of varying opacity; and
plating, the addition of one or more layers of glass to create an
impression of depth.

The Charles Engelhard Court

Decorative Arts

GALLERIES 704–707

The Museum's preeminent collections of American silver, pewter, ceramics, glass, and jewelry are installed on this level and on the Mezzanine Balcony below. Beginning in the northeast corner with 17th- and early 18th-century objects, the cases follow a chronological sequence, arranged by medium or in thematic displays intended to underscore stylistic affinities. In addition, magnificent stained-glass windows, both ecclesiastical and domestic, illustrate a variety of styles and techniques. Staircases provide access to the mezzanine below, with its outstanding collection of American art pottery.

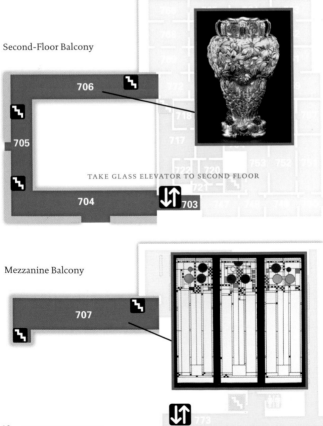

Second-Floor Balcony

706

705

704

703

TAKE GLASS ELEVATOR TO SECOND FLOOR

Mezzanine Balcony

707

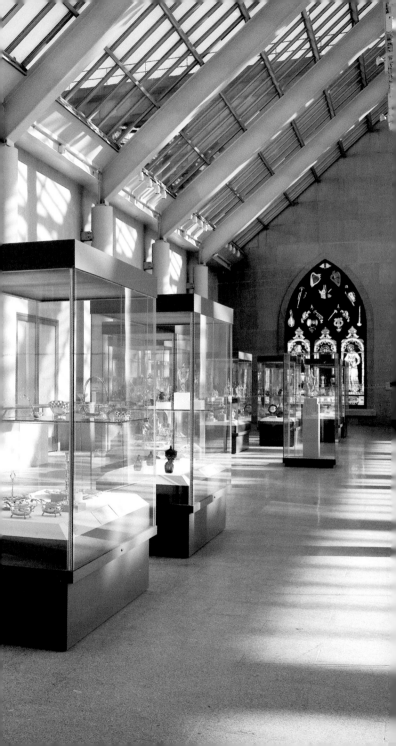

Colonial Decorative Arts, 1660–1790

American China Manufactory, *Pickle Stand*, 1770–72

New Bremen Glass Manufactory, *Covered Goblet*, 1788

John Will, *Tankard*, 1752–74

Paul Revere Jr., *Pair of Sauceboats*, ca. 1765

Displayed in the northern section of the East Balcony are colonial American silver, pewter, glass, and ceramics, including earthenware, stoneware, and porcelain. As early as the 1660s, immigrant craftsmen began to establish workshops in which they produced vessels that closely followed English and Continental fashions. Goods created during the late 17th and early 18th centuries typically reflected Baroque traditions. By the mid-18th century, again following Europe's lead, colonial American craftsmen had rejected Baroque massiveness and symmetry in favor of the lighter, more curvilinear forms of the Rococo. Imported objects and immigrant craftsmen played a central role in transmitting the latest European styles to the colonies. The objects displayed here offer insights into the domestic environments, craft traditions, and daily customs of colonial Americans.

Colonial American silver is also on view in the Roy J. Zuckerberg Gallery (750) on the second floor and, on the third floor, in the New York Dutch Room (712).

The Charles Engelhard Court

Early Years of the New Nation, 1780–1830

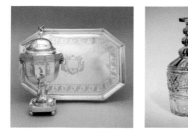

John McMullin, *Tray and Urn*, 1799

Bakewell, Page and Bakewell, *Decanter*, ca. 1826–35

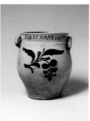

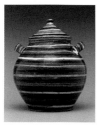

Sugar Pot, North Carolina, 1820–40

Jar, New York City, 1797–1819

The southern section of the East Balcony is devoted to objects produced when the United States was a young nation. On display is a diverse array of wares, some high style and others more utilitarian, in a variety of media, including silver, glass, earthenware, and stoneware. During this period, Neoclassicism became the prevailing aesthetic. First popular in Europe, the style quickly took hold in America, where its allusions to the classical world resonated as appropriate symbols of the new republic. Immigrant and native-born craftsmen pioneered new techniques and technologies, such as machines for making pressed glass. European-inspired decorative vocabularies also took on distinctive regional characteristics in the hands of American craftsmen, resulting in objects that helped to define the taste and style of the fledgling nation.

Additional Neoclassical silver is on view in the Roy J. Zuckerberg Gallery (750) on the second floor.

The Charles Engelhard Court

Late Classical and Rococo Revival Styles, 1815–65

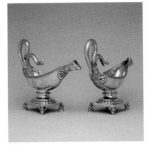 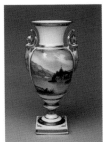

Anthony Rasch, *Pair of Sauceboats*, ca. 1815

Tucker Factory, *Vase*, 1828–38

Bottle, Ohio, 1815–45

American Pottery Manufacturing Company, *Pitcher*, 1833–50

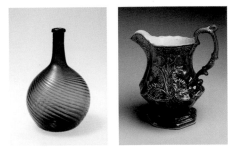

The South Balcony displays silver, ceramics, and glass ranging in date from 1815 to 1865 and reflecting keen awareness of the latest European styles. By the second decade of the 19th century, the French Empire style held sway, bringing with it a bolder, more archaeologically correct interpretation of the classical decorative vocabulary. Around midcentury, the Rococo idiom was revived, manifesting itself in exuberant, naturalistic ornament, particularly on silver and ceramic wares. These objects illustrate the growing sophistication of American artists and craftsmen, who employed technological innovations to produce an increasing variety of goods for an expanding group of consumers.

Other examples of silver, ceramics, and glass from this period are on view on the first floor in The Israel Sack Galleries (731–733) and the Martha J. Fleischman Gallery (736).

The Charles Engelhard Court

Gothic Revival Windows, 1840–70

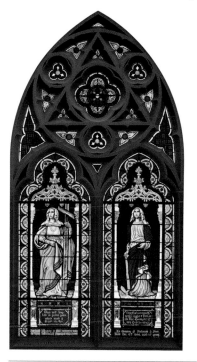

Henry E. Sharp,
Faith and Hope,
1867–69

Anchoring the south end of the East and West Balconies are
two rare surviving stained-glass windows made in New York
between 1840 and 1870. Lured by the city's burgeoning stained-
glass industry, which was spurred by a surge in church building,
talented English artists such as William Jay Bolton, his brother
John, and Henry E. Sharp brought their skills and traditions
to the growing metropolis. Largely medieval in technique, their
work combines richly colored glass, in brilliant red, blue, and
green, with painted details. Like most ecclesiastical windows of
the era, these two examples consist of symmetrical figural
compositions framed by elaborate Gothic tracery.

The Charles Engelhard Court

Aesthetic Movement, 1870–90

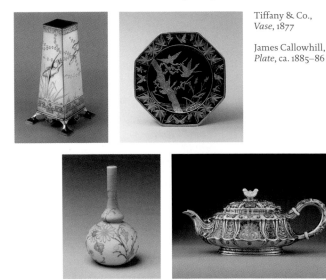

Tiffany & Co.,
Vase, 1877

James Callowhill,
Plate, ca. 1885–86

Mount Washington
Glass Company, *Vase*,
ca. 1886–94

Tiffany & Co., *Teapot*, ca. 1888

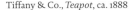

Among the 19th-century artworks on view on the West Balcony
are silver, glass, and ceramics made in the 1870s and 1880s and
characterized by an eclectic synthesis of styles, conventionalized
surface decoration, and a diversity of innovative techniques—
hallmarks of the Aesthetic movement. Like their British
counterparts, American designers found inspiration in Chinese,
Islamic, and, especially, Japanese precedents. This strong interest
in the "exotic" was translated into new forms and a creative use
of materials, often employed to simulate more precious
substances. Stylistically, the influence of Japanese art is evident
in such natural motifs as birds, fish, flowers, and insects and in
the prevalence of asymmetrical compositions.

Aesthetic movement furniture and architectural elements are on
view in the Deedee Wigmore Galleries (743) and the adjacent
McKim, Mead and White Stair Hall (741).

The Charles Engelhard Court

International Expositions, 1876 and 1893

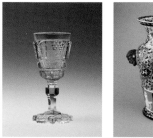

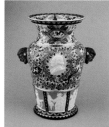

Dorflinger Glass
Works, *Wineglass*,
1876

Union Porcelain
Works, *Century Vase*,
1877

Tiffany & Co.,
Bryant Vase,
1875–76

Tiffany & Co.,
Magnolia Vase,
1893

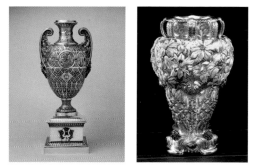

The West Balcony features a number of objects originally made
for and exhibited at the Centennial Exhibition of 1876, held in
Philadelphia, and at Chicago's World's Columbian Exposition of
1893—two of the most important international expositions of
the last quarter of the 19th century. At these venues, manu-
facturers were able to present their latest artistic and technical
achievements to an increasingly sophisticated and style-
conscious world audience. Eclectic in subject matter and unpar-
alleled in conceit, craftsmanship, and design—not to mention in
size—these presentation pieces evoked national pride through
symbolism and historical references or celebrated the country's
bounty. The exemplary objects on display here are among the
most ambitious works ever produced by the major firms of the
day, notably Tiffany & Co. and Union Porcelain Works.

The Charles Engelhard Court

Art Nouveau and Arts and Crafts, 1890–1945

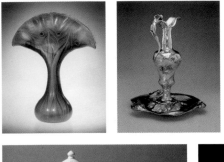

Tiffany Glass and Decorating Company, *Vase*, 1893–96

Gorham Manufacturing Company, *Ewer and Plateau*, 1901

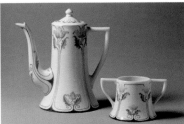

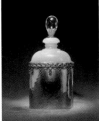

Lenox Incorporated, *Coffeepot and Sugar Bowl*, 1906

Marie Zimmermann, *Covered Jar*, 1905–15

The northern section of the West Balcony is devoted to objects made from 1890 through the first half of the 20th century. The American Art Nouveau style, heir to the French movement of the same name, was popularized in decorative arts at the turn of the 20th century. Characterized by undulating lines in both form and decoration, the style was manifested in silver by the organic shapes of Gorham Manufacturing Company's Martelé line and in glass by Louis Comfort Tiffany's Favrile confections. Following English antecedents, American designers also embraced the Arts and Crafts movement, with its reverence for handcraftsmanship and emphasis on restrained embellishment, as seen in the hammered surfaces of the metal wares displayed here.

Arts and Crafts furniture and decorative arts, as well as the work of Louis Comfort Tiffany in many media, are on view in the Deedee Wigmore Galleries (743).

The Charles Engelhard Court

Jewelry, 1700–1930

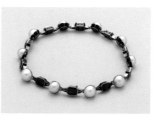

George W. Jamison and
William Rose, *Brooch*,
ca. 1835

Marie Zimmermann,
Necklace, ca. 1925

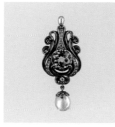

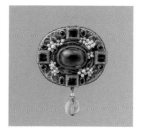

Marcus and Company,
Brooch, ca. 1900

Florence Koehler,
Brooch, ca. 1905

Examples of exquisite American jewelry from three centuries are
displayed on the West Balcony. The earliest jewelry made and
owned in colonial America was of a sentimental nature, related
to courtship and marriage or to death and mourning. Gold and
pearls as well as coral, which was believed to ward off evil,
feature prominently in early American jewelry. Throughout
the 19th century, hair jewelry enjoyed favor, as did such exotic
materials as tortoiseshell. With the discovery of diamond
deposits in South Africa in 1869, jewelry sparkled as never
before. Late 19th-century American jewelers also made use of
colored gems and native stones, such as tourmalines and
peridots. Around 1900, practitioners of the Arts and Crafts
movement effected a return to handcraftsmanship and created
superb adornments, often set with colorful enamels and
gemstones.

The Charles Engelhard Court

Art Pottery, 1876–1956

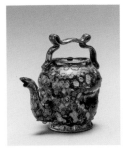

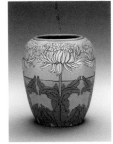

George E. Ohr,
Teapot,
1897–1900

Paul Revere
Pottery, *Vase*,
ca. 1911–12

Grueby Faience
Company, *Vase*,
1900–1908

Otto Natzler and
Gertrud Natzler,
Vase, 1956

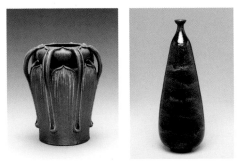

The Mezzanine Balcony showcases the Robert A. Ellison Jr.
Collection of artistic ceramics made in the United States from
1876 to 1956. The earliest examples date to the Centennial
Exhibition in Philadelphia, the catalyst for the emerging
American art pottery movement. Ceramists absorbed styles
and techniques from France, England, and the Far East, and
the tradition of painted ceramics was explored in myriad ways.
By the late 1890s, the Arts and Crafts movement had taken
hold, with its flat, simplified, and conventionalized nature
motifs executed mainly in matte glazes. The period also saw a
proliferation in glaze experiments, from the rich red of the
Chinese sang de boeuf to luster and iridescent finishes to jewel-
like crystalline surfaces. The 1920s through the 1950s reflected
the major art movements in other media and ultimately ushered
in the era of the studio potter.

The Charles Engelhard Court

Prairie School Windows, 1890–1920

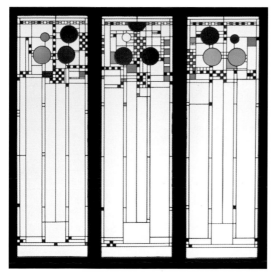

Frank Lloyd Wright, *Windows from the Avery Coonley House*, 1912

Installed on the Mezzanine Balcony are the American Wing's important holdings of leaded-glass windows by the main practitioners of the medium during the early 20th century, including Frank Lloyd Wright and George Washington Maher. Leaded-glass windows were a prominent feature of Prairie School architecture and were often incorporated into the decorative program of a home, designed as an integral part of the whole. Characterized by geometric ornament (often abstracted from a natural motif such as a grapevine or thistle), innovative use of leading, and the prevalence of transparent glass, such windows allowed for communication with the outside environment—one of the tenets of this midwestern school of architecture.

The Frank Lloyd Wright Room (745) presents a unified interior with an entire suite of leaded-glass windows.

The Charles Engelhard Court

Third Floor

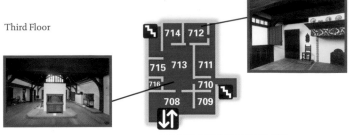

VISIT BEGINS ON THIRD FLOOR

Second Floor (2A)

VISIT CONTINUES ON FLOOR 2A

First Floor

TAKE GLASS ELEVATOR TO THIRD FLOOR

Historic Interiors and Decorative Arts (1680–1915)

GALLERIES 708–746

2

The American Wing's twenty historic interiors, or period rooms, offer a unique opportunity to walk through space and time, from Massachusetts in 1680 to Minnesota in 1915, and to experience the design evolution of the American home. The collection of period rooms was assembled over the course of a century, from the Hewlett Room fireplace wall (714), acquired in 1910, to the Worsham/Rockefeller Dressing Room (742), donated in 2010. Each interior has been painstakingly reassembled, for the most part with the original materials, to re-create as closely as possible its original size, proportions, and character, thus becoming an authentic setting for the decorative furnishings and fine art of the time. Interspersed among the rooms are galleries for the display of exceptional individual works of art.

The rooms are arranged chronologically. The 17th-, 18th-, and early 19th-century rooms are clustered on three floors behind the bank facade. The later 19th- and early 20th-century rooms continue on a lower level.

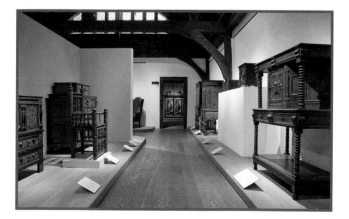

Historic Interiors and Decorative Arts (1680–1730)

GALLERIES 708–716

Third Floor

The galleries and period rooms on the third floor display the architecture and decorative arts of the early colonial period, from the mid-1600s to the mid-1700s. Small, usually low-ceilinged spaces from the New England colonies and New York represent the English and Dutch design traditions that long coexisted. They surround a large central gallery, inspired by a 17th-century Massachusetts meetinghouse (713), that houses highlights of furniture in the Seventeenth Century and William and Mary styles.

GALLERY 708 THIRD FLOOR

Early Colonial Furniture, 1660–1700

Just off the glass elevator on this floor is a gallery (708) containing highlights of early American furniture in the Seventeenth Century style, principally case pieces constructed by the joiner's panel-and-frame method and tables and chairs made of members turned on a lathe. A low door at the far end of the gallery leads to the earliest of the American Wing's historic interiors, the Hart Room (709), and the beginning of the chronological architectural circuit.

Hart Room
Ipswich, Massachusetts, 1680

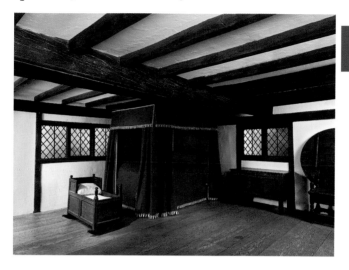

2

This room illustrates the typical architectural features of interiors built by the earliest British settlers in the New World: a low ceiling, exposed post-and-beam construction, and a vertically sheathed fireplace wall. It is the only downstairs room (a tiny staircase hall aside) from the Ipswich home of the tanner Samuel Hart, which he completed within two years of his marriage, in 1678, to Sarah Norton. The variety of furnishings, mostly from Massachusetts, suggests the room's original multipurpose use: cradle, bedstead (a modern replica hung in red wool), chest, cupboard, chairs, and table. The pieces exhibit a melding of late Renaissance and Mannerist designs from northern Europe and England and craft practices brought to the colonies by English joiners and turners.

The doorway in the fireplace wall leads to a corridor (710) with a display of goods typically imported by American colonists.

Wentworth Room and Stairs
Portsmouth, New Hampshire, 1695–1700

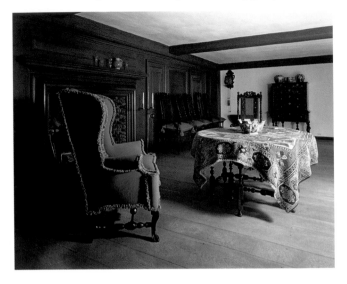

One of the largest domestic interiors surviving from the early colonial period, this room comes from the frame house built in Portsmouth by John Wentworth—a merchant who also served as lieutenant governor of New Hampshire—shortly after his marriage to Sarah Hunking in 1693. Its interior post-and-beam construction is exposed in the traditional manner, but its fireplace wall, wood-paneled with applied moldings, is a harbinger of 18th-century classicism. Though originally an upstairs bedchamber, the room is now furnished as a parlor, with some of the new furniture forms introduced with the William and Mary style: the carved and caned tall-back chair, the upholstered easy chair, and the walnut-veneered chest on a turned-leg frame (the earliest American "highboy").

On view in gallery 716 is the staircase hall from the Wentworth House. With its paneled walls and spiral-turned balusters, it is a bold provincial echo of high-style English architectural fashion of the 1670s.

New York Dutch Room and Vestibule
Bethlehem, New York, 1751

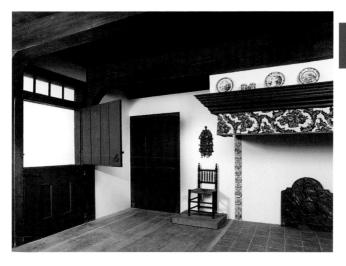

2

This room illustrates the longevity of traditional Netherlandish
building practices in communities settled by Dutch immigrants
in the Hudson River valley. It is framed with a series of massive,
parallel post-and-beam supports, called anchor bents, and it
has a jambless fireplace (one with a great hood but no side walls).
It is the main room from a house built in 1751 for Daniel Pieter
Winne, a third-generation Dutch immigrant, and it shows no
evidence of the British takeover of New Amsterdam in 1664. The
room now serves as a gallery for the display of New York–made
furniture and silver in the Dutch tradition. It is entered through
a vestibule displaying the house's original exterior wood
sheathing. The painted window installed here bears the arms of
Jan Baptist Van Rensselaer, director general of the estate of
Rensselaerwyck, where the Winne House originally stood.

The Van Rensselaer Hall (752), located within the second-floor
painting and sculpture galleries, is from the manor house at
Rensselaerwyck.

Meetinghouse Gallery

The massive timber-framed structure of this gallery is an adaptation of that of the 1681 meetinghouse in Hingham, Massachusetts—the last extant example of the once-numerous 17th-century New England meetinghouses, which were based on the halls of medieval English manor houses. Its arched beams are suggestive of an inverted ship's hull, accounting for the moniker of the surviving building, Old Ship Meetinghouse. Built in 1924 as part of the original American Wing, the gallery represents the Arts and Crafts aesthetic of that time in the exaggerated hand-working of its beams. Displayed in the gallery are outstanding examples of early colonial furniture—pieces in the Seventeenth Century and William and Mary styles popular until about 1725—together with early colonial portraits.

Hewlett Room and New York Alcove
Woodbury, New York, 1740–60
High Falls, New York, ca. 1750

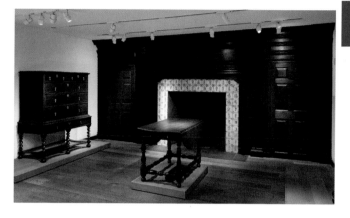

Each of these galleries features a paneled fireplace wall from a mid-18th-century house from New York State: the bright-blue-painted pine comes from the John Hewlett House on Long Island, and the red-stained gumwood from the Benjamin Hasbrouck House in the Hudson River valley. Each follows British architectural design practice as promulgated by builders' handbooks. The former (714) contains a display of early 18th-century painted furniture and ladies' accomplishments such as needlework, while the latter (715, pictured above) provides a backdrop for New York–made furniture showing both British and Dutch influence.

The reinstallation of the New York Alcove was made possible by The Peggy N. and Roger G. Gerry Charitable Trust

Historic Interiors and Decorative Arts (1730–90)

GALLERIES 717–722

The galleries and interiors on the second floor represent the late colonial period, from about 1730 to 1790. American architectural design of the period was based on the classical orders—Doric, Ionic, and Corinthian—as popularized by English builders' pattern books. In furniture, American craftsmen interpreted England's Queen Anne and Chippendale styles (Baroque and Rococo, respectively), with their focus on graceful curves and naturalistic carving.

The principal access is a staircase leading down from the third floor and opening into a large central gallery (717), off which branch period rooms from New York, Virginia, and Pennsylvania. Additional 18th-century fine and decorative arts are displayed in galleries 749–752.

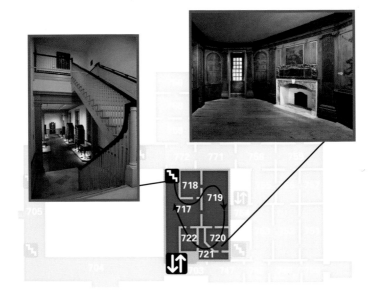

Second Floor (2A)

Late Colonial Furniture, 1730–90

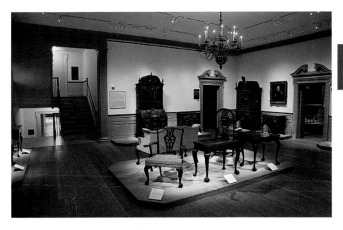

2

This gallery displays furniture made in some of the leading
18th-century American cabinetmaking centers. In 1730 Boston
was still the center of design innovation, but, beginning in the
1740s, cabinetmakers in Newport, Rhode Island, and eastern
Connecticut transformed the Boston style, adding distinctive
carved shells and scalloped profiles to case pieces and making it
more uniquely American. Farther south, Philadelphia's immi-
grant craftsmen worked in the latest London styles, grafting
playful Rococo carved ornament onto traditional Baroque forms.
In furniture, each colony had its own ideas and style.

The other major display of late colonial furniture is in gallery 751.

The Doris and Stanley Tananbaum Galleries

Verplanck Room
Coldenham, New York, 1767

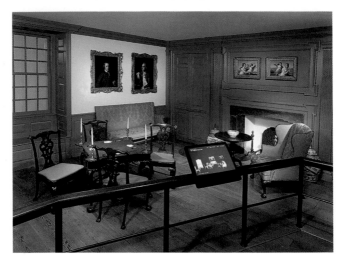

Here is a unique survival of life in colonial New York: a room
furnished entirely with one family's pre-Revolution posses-
sions, everything from portraits by John Singleton Copley and
locally made mahogany chairs and tables to imported English
furniture and Chinese export porcelains. All were owned by the
merchant Samuel Verplanck and his wife, Judith Crommelin
Verplanck, after their marriage in 1763 and were used in their
house at 3 Wall Street in New York City. Moreover, all were gifts
to the Museum from the couple's descendants. The room itself
was the front parlor of a stone house built in 1767 at Coldenham,
sixty miles north of Manhattan, for Cadwallader Colden Jr., a son
of the celebrated naturalist and New York lieutenant governor of
the same name, and his wife, Elizabeth Ellison.

The Doris and Stanley Tananbaum Galleries

Alexandria Ballroom
Alexandria, Virginia, 1792–93

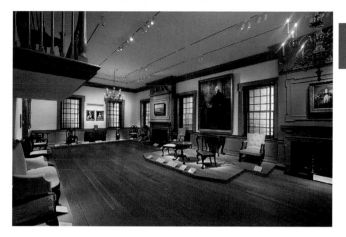

2

Intended for public assemblies and balls—note the musicians'
gallery centered in one side wall and the two projecting
chimneypieces on the other—this large and imposing room was
on the second floor of the City Hotel, built in 1792 in Alexandria,
a few miles south of Washington, D.C. The building (which still
stands) and this room in particular are of great historical interest.
George Washington's last birthday ball was held in the ballroom
in 1799, and the marquis de Lafayette was entertained in it during
his triumphal American visit of 1824. Today, the ballroom serves
as a gallery for highlights of mid-18th-century American
furniture, especially chairs and tables by the great Philadelphia
and Newport makers, and for portraits, including those of
President Washington.

The Doris and Stanley Tananbaum Galleries

Marmion Room
King George County, Virginia, 1756–70

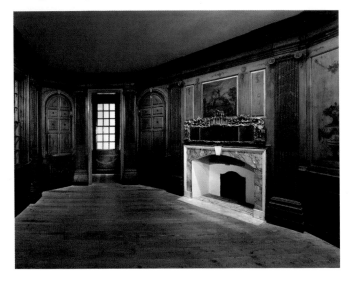

This grand seven-sided room—note the corner cupboards
flanking the far window opening—was the principal parlor of
Marmion, a plantation house built sixty miles south of
Alexandria, Virginia, around 1756 by the Fitzhugh family. The
walls, entirely sheathed with wood paneling, are typical of
southern interiors, but the later painted decoration (probably
executed in the 1770s) is uniquely ambitious: the wall panels
are embellished with picturesque landscapes and Rococo-style
ornaments, and the entablature, Ionic pilasters, and dado
paneling are marbleized in imitation of the Siena marble of the
fireplace surround. The room is shown unfurnished to enable a
close study of this world of luxurious fantasy.

Displayed in the adjacent corridor (721) are 18th-century
architectural elements.

The Doris and Stanley Tananbaum Galleries

Powel Room
Philadelphia, Pennsylvania, 1765–71

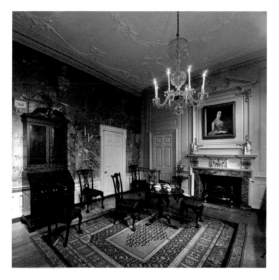

2

This room represents a fashionable domestic interior in the
largest city in British North America on the eve of the American
Revolution. It is furnished as a parlor for formal receptions
and teas, with multiple chairs and tables and even a desk and
bookcase—all examples of the richly carved Rococo-style
furniture made by Philadelphia craftsmen in the best London
fashion. The ornamental plaster ceiling and 18th-century
Chinese wallpaper, added in the 1920s, reflect that period's
Colonial Revival style.

The house, located at 244 South Third Street in Philadelphia,
was constructed in 1765–66 and was remodeled by Samuel Powel
in 1769–71. It is redolent of American history: Powel, the last
mayor of Philadelphia under British rule and the first after the
American Revolution, hosted many members of the Continental
Congress, including the future presidents George Washington,
John Adams, and Thomas Jefferson.

The Doris and Stanley Tananbaum Galleries

Historic Interiors and Decorative Arts (1790–1820)

GALLERIES 723–730

The period rooms and galleries on this part of the first floor represent the era of the young republic, also known as the Federal period, beginning with the ratification of the Constitution of the United States in 1788 and lasting until about 1820. After thirteen years of political estrangement, Americans were anxious to catch up with British fashion. In architecture, they adopted the Neoclassical style associated with the architect Robert Adam; in furniture, the Neoclassical designs popularized in the illustrated pattern books of George Hepplewhite and Thomas Sheraton. Design was now all about straight lines and geometric shapes; proportions were light and attenuated.

Access to this floor is from a staircase leading down from the second floor to a large central gallery (723), off which branch period rooms and settings from Maryland, Virginia, New York, Massachusetts, and Pennsylvania.

First Floor

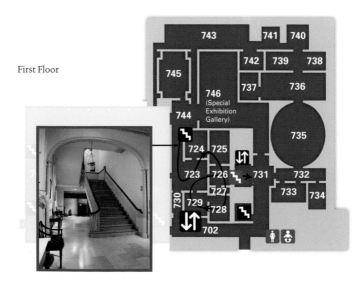

Neoclassical Style, 1790–1810

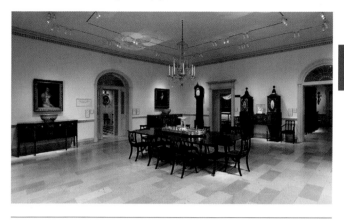

2

This stately square gallery (723), which opens directly onto The Charles Engelhard Court, displays masterpieces of American furniture in the Federal, or Neoclassical, style. The distinctive interpretations characteristic of the major urban centers are represented by the works of Thomas Seymour (Boston), Duncan Phyfe (New York), and John Davey (Philadelphia). Inlaid sideboards and a large dining table acknowledge the new importance of formal dining, while a unique twin-turreted lady's writing desk highlights both the influence of the Englishman Thomas Sheraton's engraved designs and the increase in women's education. The adjoining corridor (730) features examples of furniture from Philadelphia.

James and Margaret Carter Federal Gallery (723)

Baltimore Room and Benkard Room
Baltimore, Maryland, 1810–11
Petersburg, Virginia, ca. 1811

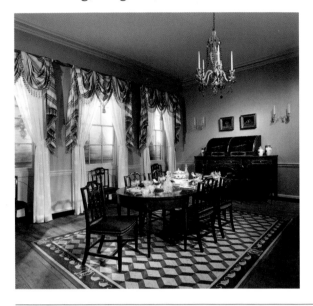

These two interiors exemplify the spread of Robert Adam's Neoclassical taste in the southern United States. An understated approach is apparent in the simple reeded moldings of the room from the town house of the Baltimore shipowner Henry Craig (724, pictured above), and a much more exuberant approach in the extensive use of cast ornament in the room from Petersburg (725). The Baltimore room is furnished as a dining room—the era's new center of fashionable home entertaining. The dining table, set with French porcelain for the American market, sits on a painted floor cloth; a sideboard, for storing table settings, dominates the back wall. The room from Petersburg, named for the early collector Bertha King Benkard, is furnished mostly with New York–made pieces given in her memory.

Early Classical Style, 1810–20

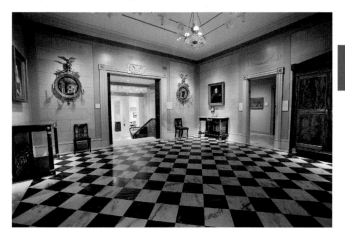

2

Architecturally, this gallery mimics the entrance hall of an American home of the 1820s or 1830s. The wood trim is from a house built around 1825 in Rye, New York; the faux-ashlar-masonry wall painting was copied from the hall of the Richard Alsop IV House (1838–39) in Middletown, Connecticut. The furniture—including several pieces by the Paris-trained *ébéniste* Charles-Honoré Lannuier, who was active in New York City from 1801 to 1819—is in the Neoclassical style known to the French as *le style antique*. By the late 1790s French craftsmen had begun to emulate ancient Greek and Roman forms in an attempt to revive the lost grandeur of antiquity. This taste spread to England and the United States, where it was defined by figural carving and lavish ornamentation with costly materials such as rosewood and mahogany veneers, marble, and gilded brass and gesso.

American Needlework, 1790–1840

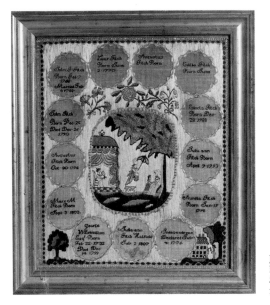

Julia Ann
Fitch,
Sampler,
1807

The Federal period was the golden age of American sampler
making, as demonstrated by the variety and beauty of the
examples in this gallery. The era saw the flowering of the private
girls' schools known as ladies' academies, where girls learned
such genteel skills as music, art, and needlework; academic
subjects were usually of secondary importance. Many of the
samplers seen here were made at these schools.

By the 1840s, however, sampler making was on the wane.
Training girls to make decorative needlework lost popularity
with the founding of public schools, where an academic educa-
tion was available to all, free of charge. Rather than artistic
pursuits, the new public schools taught courses that enabled girls
to be competent homemakers and knowledgeable mothers or
even to pursue professional careers.

Richmond Room and Haverhill Room
Richmond, Virginia, 1810–11
Haverhill, Massachusetts, ca. 1800

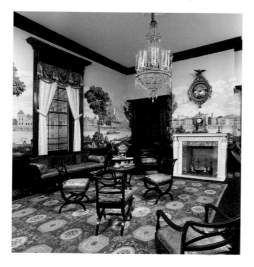

2

Architecturally, the Richmond Room (728, pictured above) is one of the most luxuriously fitted out of all early 19th-century southern interiors. The cornice, window and door frames, and dado paneling are made of solid mahogany from the Caribbean; the baseboard, of blue-and-gray marble from King of Prussia, Pennsylvania. The printed French scenic wallpaper, titled *Monuments de Paris*, is a reproduction of a design popular in the United States in the 1810s. The mahogany and rosewood furniture from the shops of Charles-Honoré Lannuier and Duncan Phyfe is the best that New York had to offer.

The next gallery (729), originally the parlor of the merchant James Duncan Jr.'s residence in Haverhill, thirty miles north of Boston, exhibits the lower ceiling and smaller scale of houses built in more northern climates. Notable among its New England furnishings is a great carved bed attributed to the Boston cabinetmaker Thomas Seymour.

Historic Interiors and Decorative Arts (1820–1915)

GALLERIES 731–745

The 19th century was a time of heightened historical awareness, coupled with an unprecedented uncertainty about what the proper style for the times should be. Accordingly, the galleries and rooms on this part of the first floor display a dizzying array of different styles. In addition to a rare painted panorama and a Shaker period room, the historic interiors represent the classical (1820–40), Rococo (1840s), Gothic (1840–60), and Renaissance (1870s) revivals; the Aesthetic (1875–95) and Arts and Crafts (1900–1920) movements; and the styles associated with the two leading designers of the late 19th century, Louis Comfort Tiffany and Frank Lloyd Wright.

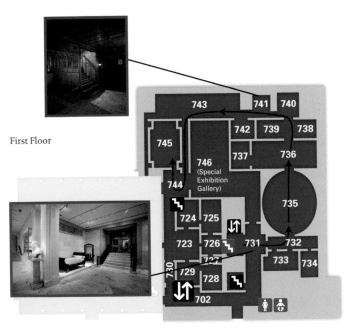

First Floor

Classical Style, 1810–45

2

The arrangement and detailing of these galleries pay homage to the Greek Revival style and were directly inspired by two important surviving buildings, Alexander Jackson Davis's magnificent Colonnade Row (1833), on Lafayette Place in Lower Manhattan, and the Richard Alsop IV House (1838–39), on the campus of Wesleyan University in Middletown, Connecticut. The arts of the period 1810 to 1845 are on display here, including furniture, silver, ceramics, glass, sculpture, and paintings. The furniture and decorative arts freely mix Greek and Roman details and employ many ancient decorative motifs and forms. Note especially the pair of grand silver urns presented to Governor DeWitt Clinton in 1825 at the opening of the Erie Canal.

A Corinthian column from Colonnade Row is on view in The Charles Engelhard Court (700).

The Israel Sack Galleries

Shaker Retiring Room
New Lebanon, New York, ca. 1830–40

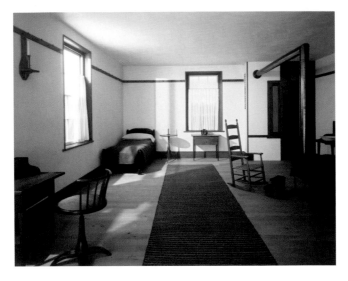

After the Revolution, many Americans joined recently formed
Protestant sects with distinctive spiritual and social emphases.
One of these groups was the Shakers, formally known as the
United Society of Believers in Christ's Second Appearing. The
Shakers' utopian communities were ahead of their time in the
practice of social, sexual, economic, and spiritual equality for all
members. This room, from the North Family Dwelling in the
Shaker community of New Lebanon, exhibits the most salient
characteristics of Shaker design: simplicity and utility. It has
white plaster walls, plain stained woodwork, and a scrubbed pine
floor. All the furniture, from the built-in chest of drawers and
cast-iron heating stove to the bedstead, chairs, and tables, was
made by Shakers, either at New Lebanon or in other Shaker
communities in the northeastern United States. Much of the
furniture in the room came to the Museum through the collec-
tion of Faith and Edward Deming Andrews, who, in the 1930s,
began documenting the lives, beliefs, and crafts of the Shakers.

Vanderlyn Panorama, 1818–19

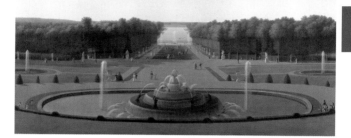

John Vanderlyn, *Panoramic View of the Palace and Gardens of Versailles*, 1818–19
(detail)

The painting covering the curved walls of this room, by John
Vanderlyn of New York, is a rare survivor of a form of public art
and entertainment that flourished in the 19th century. Invented
in Great Britain in the 1780s, panoramas (Greek for "all sight")
were displayed in the darkened interiors of cylindrical buildings,
or rotundas. Illuminated by concealed skylights, the circular
paintings offered the illusion of an actual landscape surrounding
the viewer. Visitors paid a small admission fee and were
rewarded with vicarious travel to different parts of the world.

Vanderlyn chose the subject of Versailles to introduce Americans
to the splendors of French culture, which also informed his
historical paintings; the latter were exhibited downstairs from
the panorama in Vanderlyn's Rotunda, a Palladian-style building
located behind City Hall in Manhattan—in effect, New York
City's first art museum.

The Lawrence A. and Barbara Fleischman Gallery

Revival Styles, 1850–75

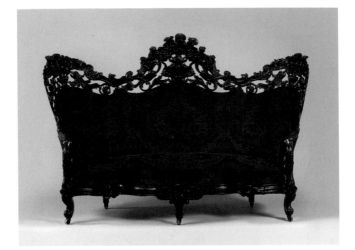

John H. Belter, *Sofa*, 1850–60

The 1850s and 1860s were an era of great industrial, political, and artistic change in the United States. During the prosperous period just before the Civil War, and in the Reconstruction era after the war, the country struggled to come to terms with its national identity and create a unique and coherent American culture. The middle decades of the 19th century were character-ized by rapidly growing cities, populated by a large, newly formed middle class and a huge influx of immigrants. Trained craftsmen, fleeing political unrest in Europe, brought their skills to bear on many growing industries, especially cabinetmaking. The furniture in this gallery, created primarily by German and French immigrants, was inspired by traditional European styles, but it is truly American in its bold and ebullient carving and unabashedly rich surface decoration.

Martha J. Fleischman Gallery

Renaissance Revival Parlor
Meriden, Connecticut, 1870

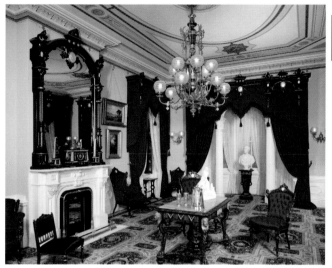

2

The Renaissance Revival style, fashionable in the 1870s, is shown in all its glory in this rear parlor, or sitting room, from the "princely residence" built in central Connecticut for the carpet-bag and hoopskirt manufacturer Jedediah Wilcox. The original decorative ensemble is remarkably intact—everything from the painted ceiling, massive oak doors, and marble mantel, to the overmantel mirror, gas chandelier, and wall sconces, to the matching suite of tables and seating furniture.

Greek Revival Parlor
New York, New York, ca. 1835

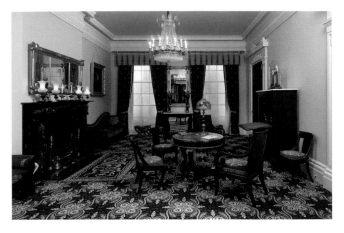

This room in the mature Greek Revival style of the 1830s
re-creates half of the double parlor of a first-class Manhattan
row house. It integrates authentic elements (the monumental
Ionic columnar screen, the black marble mantel, and the
mahogany doors that would have separated the front and back
parlors) and replicas based on contemporary pattern books
(the plaster cornice and ceiling rosette and the side doors). The
furniture—a suite of chairs and chaises made for the lawyer
Samuel A. Foote in 1837—is in the most up-to-date Grecian Plain
style and is firmly attributed to Duncan Phyfe, New York's
leading cabinetmaker.

Richard and Gloria Manney Rooms

Rococo Revival Parlor
Astoria, New York, 1840–50

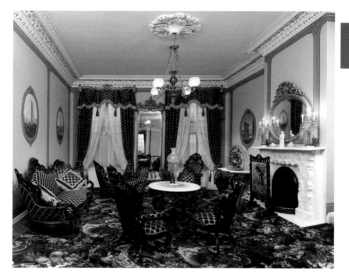

2

This room represents the Rococo Revival style of the mid-19th century at its most florid. The principal architectural elements—the Corinthian columnar screen and cast-plaster cornice—come from a suburban villa built in 1852 by the hat merchant Horace Whittemore in Astoria, overlooking the East River and Manhattan. The white marble mantel, multihued floral carpet, and richly carved rosewood furniture represent the highest fashion displayed in more formal city parlors. The furniture is attributed to John Henry Belter, a German immigrant to New York, who patented a method of lamination whereby wood could be bent into deep curves and then elaborately carved.

Richard and Gloria Manney Rooms

Gothic Revival Library
Newburgh, New York, 1859

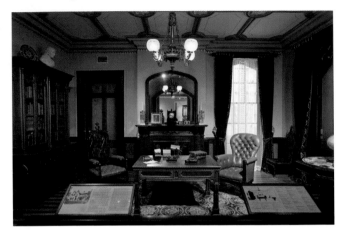

With its pointed-arch openings and pierced trefoils, this room represents the Gothic Revival, an occasional alternative during the 1840s and 1850s to the Greek, Rococo, and other fashionable revival styles. Because of its literary associations, the Gothic was favored for libraries, particularly in the Hudson River valley; this example is from Morningside, a brick country house built near Newburgh in 1859 by the British-trained architect Frederick Clarke Withers for Frederick Deming, president of the Union Bank of New York. Withers came to the United States to work with the famed landscape designer Andrew Jackson Downing. Most of the furniture in the room is either oak or walnut and was produced in New York City from the early 1850s to the mid-1860s.

McKim, Mead and White Stair Hall
Buffalo, New York, 1884

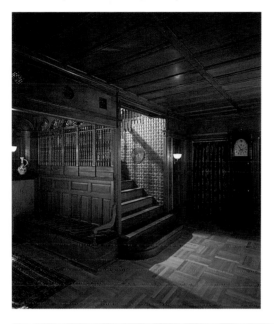

2

This stair hall exhibits the complex spatial and light effects with which young architects, bored with turning out rooms that were mere cubes to be furnished in one or another revival style, began to experiment in the early 1880s. Adjacent to the staircase is a sitting area with a fireplace and built-in benches, known as an inglenook. The low-ceilinged spaces, clad in clear-finished oak, reflect a new sensibility that referenced the early American past—the beginnings of the Colonial Revival. The hall comes from a house commissioned in 1882 by Erzelia F. Metcalfe of Buffalo and is an early work by the famous New York architectural firm McKim, Mead and White.

Worsham-Rockefeller Dressing Room
New York, New York, 1881

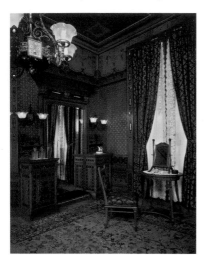

The dressing room that Arabella Worsham commissioned in
1881 for her house at 4 West 54th Street in Manhattan—she sold
the house to John D. Rockefeller in 1884, when she married
Colis Huntington—is one of the most elaborate interiors of the
Aesthetic period. Designed by the little-known New York firm
George A. Schastey and Co., it is a jewel box of a room. It features
the finest materials: elaborate woodwork in satinwood, with
marquetry of rosewood and mother-of pearl; wallpaper; a
painted ceiling; and a frieze of cupids holding garlands of shells
and jeweled necklaces. The delicate dressing table, chairs, and
dressing mirror were all designed en suite with the built-in
woodwork. The cohesive interior is a quintessential artistic
expression of America's Gilded Age.

Aesthetic Movement, 1875–95

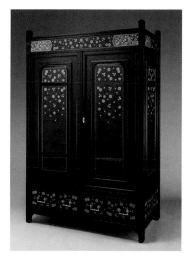

2

Herter Brothers,
Wardrobe, 1880–85

The Aesthetic movement in furniture, metalwork, ceramics, stained glass, textiles, wallpapers, and books evolved out of mid-19th-century British ideas aimed at reforming the arts in the wake of the Industrial Revolution. The movement's adherents embraced ornament and forms from a variety of non-Western sources, especially from Japan, China, and the Islamic world. The catalyst for the movement's widespread popularity in the United States was the Centennial Exhibition of 1876 in Philadelphia, and Aestheticism remained a force through the mid-1880s. The period saw a proliferation of arts publications, clubs, and societies; an intense interest in collecting artworks; and the founding of many of the nation's major art museums. Domestic interiors by designers such as Herter Brothers and Louis Comfort Tiffany, with furnishings and decorative finishes created for fully integrated room ensembles, best expressed the tastes of the era.

Deedee Wigmore Galleries

Arts and Crafts Movement, 1900–1920

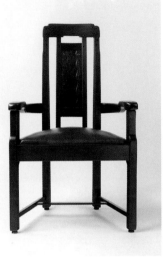

Greene and Greene,
Armchair, 1907–9

Overlapping with the Aesthetic movement in some important
respects and also originating in England, the Arts and Crafts
movement was a reaction against dehumanization in an
increasingly industrial world. Arts and Crafts reformers
advocated a return to medieval craft systems and schools of
design and shared the goal of simplifying and unifying work and
environment—a principle espoused by both the art critic John
Ruskin and the designer and Socialist William Morris. Not so
much a specific style as an overriding philosophy, the movement
advocated handcraftsmanship, honesty in materials, and
minimal decorative embellishment. In the United States, its
most successful practitioners were in the studios of Gustav
Stickley on the East Coast and Greene and Greene on the
West Coast. Utopian and craft-centered communities such as
Rose Valley in Pennsylvania and Byrdcliffe in New York forged
individual styles within the Arts and Crafts mode. The
movement also saw the beginning of a larger movement of art
pottery, with progenitors in centers across the country.

Deedee Wigmore Galleries

Louis Comfort Tiffany, 1870–1925

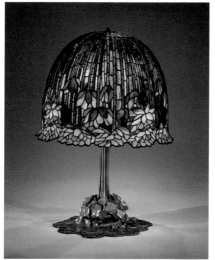

2

Louis Comfort Tiffany,
Table Lamp, 1904–15

This gallery serves as a testament to Tiffany's lifelong interest
in exotic sources, unconventional materials, and motifs drawn
from nature. Louis Comfort Tiffany (1848–1933) was one of the
most acclaimed and multitalented artists working in America
in the late 19th and early 20th centuries. In a career that lasted
more than half a century, from the 1870s through the 1920s, he
embraced virtually every artistic and decorative medium,
designing and directing his various studios to produce windows,
mosaics, lighting, glass vessels, pottery, metalwork, enamels,
jewelry, textiles, and interiors. The only son of Charles Lewis
Tiffany, founder of the eponymous New York jewelry and silver
firm, Louis began his career as a painter before embracing
decorative work in the late 1870s. He sought inspiration in
the arts of the Near and Far East. At the same time, he revered
nature, and native flowers and plants were critical stimuli to
his creative output.

Deedee Wigmore Galleries

Frank Lloyd Wright Room
Wayzata, Minnesota, 1912–14

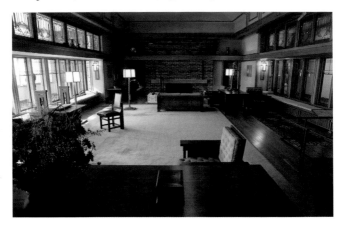

This room (745), the latest of the American Wing's historic
interiors, is the work of the most famous architect America has
yet produced: Frank Lloyd Wright (1867–1959). It was designed
as a large, freestanding reception room at one end of a house built
for Mr. and Mrs. Francis W. Little near Minneapolis in 1912–14.
With its low-pitched roof, broad, overhanging eaves, unpainted
oak trim, and banks of clear leaded-glass windows inviting the
natural world inside, it is representative of Wright's signature
Prairie-style domestic architecture. The furniture, all designed
by Wright, is placed exactly as he planned it, making of the
ensemble a complete and unified work of art.

Directly outside the room is a gallery (744) dedicated to the work
of Wright and his contemporaries, which also serves as the
entrance to The Erving and Joyce Wolf Gallery for special
exhibitions (746).

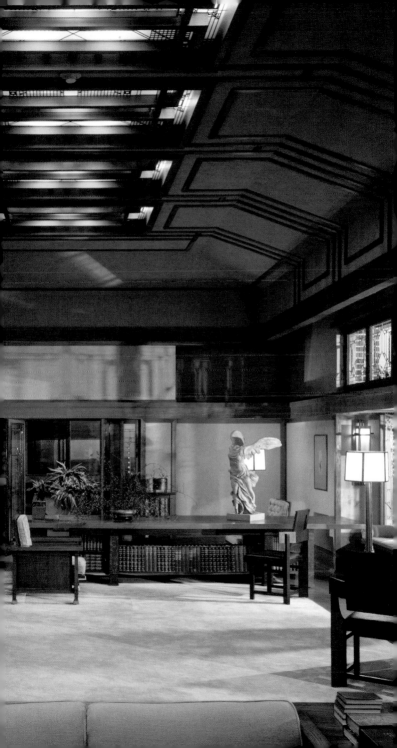

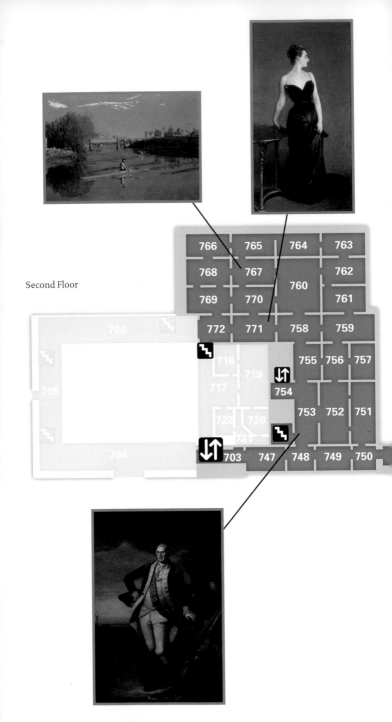

Second Floor

766 | 765 | 764 | 763
768 | 767 | 762
| | 760
769 | 770 | 761
772 | 771 | 758 | 759

706

718 | 719
717
755 | 756 | 757
754
705
722 | 720
753 | 752 | 751
721
704
703 | 747 | 748 | 749 | 750

Paintings and Sculpture

GALLERIES 747–772

Anthony W. and Lulu C. Wang Galleries
of Eighteenth-Century American Art

The Joan Whitney Payson Galleries

3

The second-floor galleries offer the principal display of the American Wing's magisterial collections of paintings, small-scale sculpture, and 18th-century silver. The Anthony W. and Lulu C. Wang Galleries of Eighteenth-Century American Art (747–754) are devoted to paintings and architecture, furniture, silver, and other decorative arts. The Joan Whitney Payson Galleries (755–772) provide thematic groupings, in a broadly chronological order, of paintings and sculpture of the 19th and early 20th centuries. All of the galleries, with their coved or barrel-vaulted ceilings, skylights, oak floors, and limestone trim, pay contemporary homage to traditional Beaux-Arts museum design.

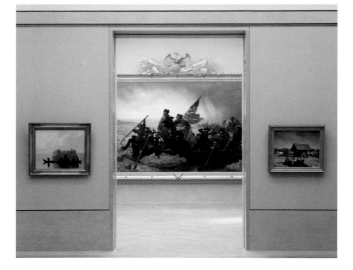

Colonial Portraiture, 1730–76

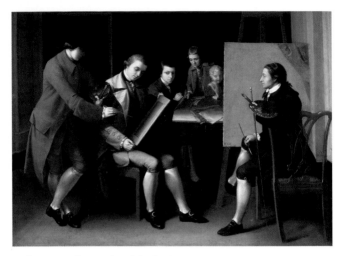

Mathew Pratt, *The American School*, 1765

Anthony W. and Lulu C. Wang Galleries

By the beginning of the 18th century, portraiture was firmly
established in colonial American cities as an art form embodying
the ideals and tastes of a wealthy society. This gallery includes
examples by the Scottish émigré John Smibert—who arrived in
Rhode Island in 1729 with considerable skills and academic
training and settled in Boston—as well as by America's first
eminent native-born painter, John Singleton Copley, who
created opulent images that captured his sitters' hopes and values
on the eve of the American Revolution. The approaching war
deprived many native-born artists of the opportunity to receive
formal training in European artistic traditions. Still, the most
ambitious followed Benjamin West to London, where his studio
became the leading school for aspiring American painters.

The George M. and Linda H. Kaufman Galleries

John Singleton Copley

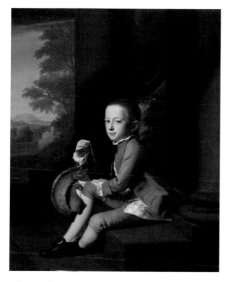

3

John Singleton Copley, *Daniel Crommelin Verplanck*, 1771

Anthony W. and Lulu C. Wang Galleries

More portraits by John Singleton Copley (1738–1815) grace this
gallery. Before leaving his native Boston for England in 1774,
Copley had become the leading portraitist of the colonial era.
Throughout New England and New York, he depicted contem-
porary merchant princes, political leaders, clergymen, and
their wives and children. Taking his cues from John Smibert
and Joseph Blackburn, whom he quickly surpassed in skill and
ingenuity, Copley studied mezzotints after contemporary
British canvases the better to serve his discriminating Anglophile
clients—American noblewomen of intelligence and high char-
acter and men who appreciated his gift for conveying aristocratic
elegance and gentility. His career was a triumph, and he later
established a highly successful practice as a portraitist and history
painter in London. Hanging from the vaulted ceiling is William
Rush's grand-scale carved-and-gilded eagle in full flight.

The George M. and Linda H. Kaufman Galleries

Life in America, 1700–1800

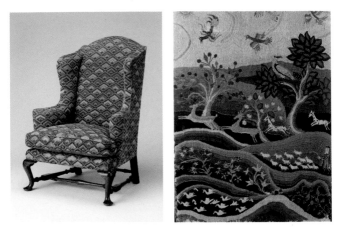

Caleb Gardner, *Easy Chair*, 1758 (front and back views)

Anthony W. and Lulu C. Wang Galleries

American colonists, like people of many periods and cultures, cherished bright colors and ornament. Decorative painting on walls and furniture, woven or embroidered textiles, and drawings and engravings on paper were the principal vehicles by which they expressed this taste. A selection of precious survivals from the 18th century are displayed in this gallery, on a rotating basis in the case of light-sensitive materials. Textiles include quilts, coverlets, and bed hangings; needlework samplers and pictures; and upholstery on furniture. Works on paper range from exquisitely drawn pastel portraits by the likes of John Singleton Copley to engraved representations of historical events, such as those by Paul Revere.

Joyce B. Cowin Gallery

Silver, 1660–1800

Cornelius
Kierstede, *Bowl*,
1700–1710

Myer Myers,
Basket, 1770–76

John Hull and Robert
Sanderson Sr., *Wine Cup*,
ca. 1660

Paul Revere Jr., *Hot-
Water Urn*, 1791

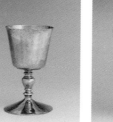

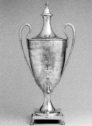

3

Anthony W. and Lulu C. Wang Galleries

The American Wing's finest 17th- and 18th-century silver is
presented in this treasury of domestic, ecclesiastical, and
presentation objects. The earliest feature fluted gadrooning,
engraving, and cast or embossed ornament reflecting late
Renaissance and Baroque traditions. Lighter, more curvilinear
Rococo designs predominate during the 1760s and 1770s,
followed by a return to order and restraint with the arrival of
Neoclassicism in the post-Revolutionary period. Americans
presented communion silver to their houses of worship and
commissioned vessels to mark special occasions. Appropriately
inscribed, silver was, and remains, the ideal choice for honoring
personal, civic, and professional accomplishments. As a tangible
index of social standing, it has always represented financial
security and sophisticated taste.

American silver of the 17th through early 20th century is also
displayed on the balconies of The Charles Engelhard Court
(704–706).

Roy J. Zuckerberg Gallery

Late Colonial Furniture, 1730–90

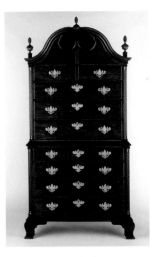 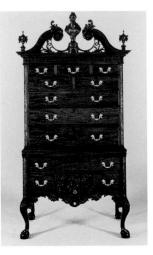

Thomas Townsend, *Chest-on-Chest*, Newport, ca. 1772

High Chest of Drawers, Philadelphia, 1762–65

Anthony W. and Lulu C. Wang Galleries

The furniture in this gallery, mostly mid-18th-century cabinetwork—chests, desks, and clock cases—was heavily influenced by the classically inspired architecture of the houses for which it was intended. The scroll pediments that often cap the best of the high chests and chests-on-chests echo the serpentine curves atop fancy front doorways. (An example from the Connecticut River valley is installed here on one wall.) The most prestigious and, indeed, the most uniquely American of these pedimented case pieces was the high chest of drawers, or "highboy," raised on tall, gracefully curved legs.

More furniture of this period can be seen in galleries 717 and 719.

Van Rensselaer Hall
Albany, New York, 1765–69

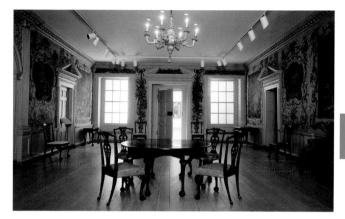

Anthony W. and Lulu C. Wang Galleries

3

The Anglo-Palladian manor house built over a four-year period
by Stephen Van Rensselaer II on the outskirts of Albany after
his marriage to Catherine Livingston in 1764 was public
confirmation that British culture had finally, a full century after
the takeover of New Amsterdam in 1664, supplanted that of
the Dutch in the Hudson River valley. Until then, the Van
Rensselaers, among the earliest Dutch settlers of New York and
long the region's largest landowners, had lived, like their tenants,
in traditional Dutch farmhouses (see the New York Dutch
Room; gallery 712). The new manor's entrance hall, the grandest
and best preserved of all domestic interiors from the New York
colony, proudly aped London's version of the French Rococo.
The woodwork includes leafy carved panels taken from a just-
published carvers' design book. The grisaille wallpaper—the
decorative program includes depictions of classical Roman
landscapes and the four seasons, all within elaborate frames—
was hand painted in London specifically for the room. This was
as close as an American colonist could get to collecting and
decorating with framed European oil paintings.

The Virginia and Leonard Marx Gallery

Era of the Revolution, 1776–1800

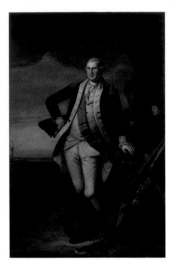

Charles Willson Peale,
George Washington, ca. 1780

Anthony W. and Lulu C. Wang Galleries

American colonists had a fierce sense of their privileges as
English subjects, and, over time, they developed a distinctly
American understanding of their rights and liberties and were
willing to fight for them. The paintings seen in this gallery
express the pride of a young nation born of revolution and cele-
brate its heroes and hard-fought battles. Following their study
abroad, the American painters Charles Willson Peale, John
Trumbull, and Gilbert Stuart returned from London to the United
States, where they made life portraits of George Washington
to exalt him in his roles as war hero and chief executive of the
United States. His image, reproduced frequently in paintings,
sculpture, and other media, symbolized the legitimacy of the
newly independent nation and embodied the ideals of honesty,
virtue, and patriotism. The first American-born artist to gain
international prominence, Benjamin West, working in London,
advanced the genre by painting scenes from contemporary
history.

The George M. and Linda H. Kaufman Galleries

Portraits in Miniature, 1750–1920

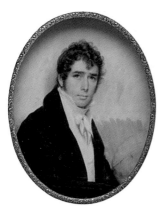

Joseph Wood, *Self-Portrait*, ca. 1810

Anthony W. and Lulu C. Wang Galleries

The tradition of miniature painting—tiny watercolor portraits
on ivory—emerged in America in the 18th century. Based on
European models, portrait miniatures are related to ancient and
medieval devotional paintings and illuminated manuscripts.
Originally made to be worn or carried, each is inextricably tied to
its function as memento, love token, or reliquary. The works in
this gallery portray husbands, wives, lovers, and children, both
living and dead, and commemorate births, deaths, and marriages.
The miniatures have been placed in a range of mounts, including
metal lockets, other types of jewelry, and pocket-sized leather
cases. After the invention of the daguerreotype in 1839, many
miniaturists abandoned their art, but some chose to compete
with photography. A later revival of the tradition endured into
the early decades of the 20th century.

3

Faces of the Young Republic, 1789–1800

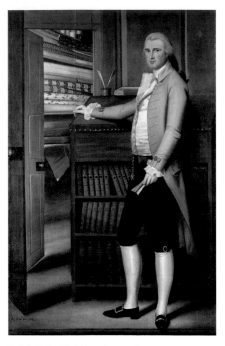

Ralph Earl, *Elijah Boardman*, 1789

The Joan Whitney Payson Galleries

The struggle for independence had isolated the colonies artistically as well economically, but the years following the cessation of hostilities with Britain were ones of steady growth and, beginning in 1785, saw the return from London of the country's most talented artists. Gilbert Stuart rose to prominence as America's leading urban portraitist, while Ralph Earl offered his considerable talents to the country's emerging rural middle class. The proud new citizens of the United States had much to celebrate in their domestic, commercial, and professional lives in the post-Revolutionary period, and many commissioned portraits—such as those seen in this gallery—that reflected their patriotism as well as their social status.

Portraiture and Still Life, 1800–1850

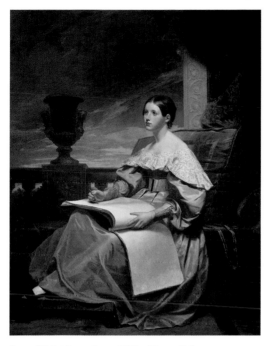

3

Samuel F. B. Morse, *Susan Walker Morse*, 1836–37

The Joan Whitney Payson Galleries

In the early 19th century, portraiture remained the focus for younger artists such as Thomas Sully and Samuel F. B. Morse, who executed portraits in the grand manner and in a painterly style. The best American portraitists of the Victorian era aimed for something more than straightforward likenesses—they painted *fancy* pictures, not just of individuals but of social types such as street vendors, that often contained poetic or provocative elements. Members of the Peale family of Philadelphia introduced still life as a worthy subject and highlighted both imported luxury goods and locally grown fruits and vegetables in their meticulously rendered paintings. Nature's bounty took on an exaggerated quality in the profusely abundant still lifes of the German-born Severin Roesen.

Art in the Folk Tradition, 1800–1900

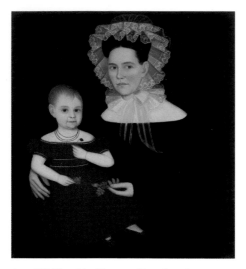

Ammi Phillips, *Mrs. Mayer and Daughter*, 1835–40

The Joan Whitney Payson Galleries

The Museum's collection of folk art—represented by many
of the works in this gallery—was largely established in 1980 by
the bequest of Colonel Edgar William and Bernice Chrysler
Garbisch, who, like many collectors in the field, discovered folk
art through 20th-century eyes. The term "folk art" refers to a
broad range of artistic approaches that are nevertheless unified
by conventions of method, aesthetics, and circumstance. Most
folk artists were, in fact, highly trained and multitalented, even
though they spent their careers moving from place to place
courting local audiences. Almost all favored strong colors,
broad paint application, patterned surfaces, and skewed scale
and proportion. They developed compositional formulas that
allowed them to work quickly, with limited materials and in
makeshift studios. With the introduction of photography in 1839,
some folk artists rose to the challenge by embracing the new
medium—themselves becoming photographers—and some by
continuing to compete with it.

Barbara and Martha Fleischman Gallery

Life in America, 1830–60

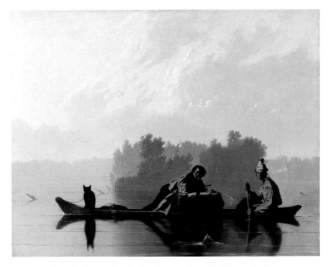

3

George Caleb Bingham, *Fur Traders Descending the Missouri*, 1845

The Joan Whitney Payson Galleries

During the decades leading up to the Civil War, American artists adopted new modes of pictorial storytelling, primarily in the form of genre paintings featuring narratives that the growing audiences for art could easily understand. The paintings on view in this gallery are characterized by clearly delineated forms and compositions and are often humorous, didactic, or moralizing. Domestic scenes of lower- and middle-class characters were often inspired by Dutch old masters or more recent French and British popular prints. Such universal themes as childhood, marriage, family, and community persisted in paintings by Francis William Edmonds and Lilly Martin Spencer, while the everyday functioning of our democracy—political elections, attitudes toward race and immigration, the frontier as reality and myth—was explored and depicted in works by William Sidney Mount and George Caleb Bingham.

Alice-Cary and W. L. Lyons Brown Gallery

Emergence of the Hudson River School, 1815–50

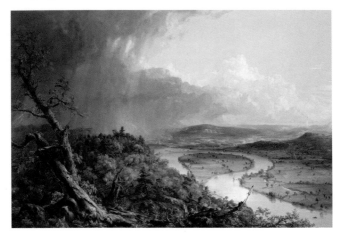

Thomas Cole, *View from Mount Holyoke, Northampton, Massachusetts, after a Thunderstorm—The Oxbow*, 1836

The Joan Whitney Payson Galleries

The term Hudson River School, first used in the 1870s as a dismissive epithet, is now generally accepted as an appropriate description of the dominant artistic vision that held sway in the United States from 1825 until 1875. The original, loosely knit group of artists and writers rose to prominence in New York City during the early 19th century. With Thomas Cole as their leader, they created an American landscape vision based on the exploration of nature, seen as a resource for spiritual renewal and an expression of cultural and national identity. The first painter to portray America in its wilderness state, Cole, with his early views of the Northeast, inspired successive generations of artists to embrace heroic landscape subjects grounded in the notion that what defined Americans was their relationship with the land.

Jack and Susan Warner Gallery

History, Landscape, and National Identity, 1850–75

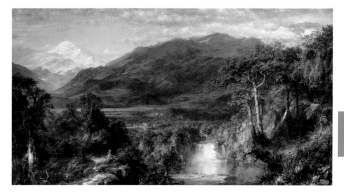

Frederic Edwin Church, *Heart of the Andes*, 1859

The Joan Whitney Payson Galleries

After 1850, artists of the Hudson River School looked for inspiration farther from home, seeking to measure the experience of their own regional and national landscapes against wilderness experiences in the West, the Arctic, and the Andes. They also traveled to Europe, confronting and interpreting long-venerated Old World sites. During the Civil War era, landscape painting attained unprecedented status in American art. Leading artists, including Frederic Edwin Church and Albert Bierstadt, employed larger canvases to promote expanding notions of landscape that rivaled history paintings (such as Emanuel Leutze's *Washington Crossing the Delaware*, pictured on page 61) in both scale and message. Their entrepreneurial spirit resulted in the "great picture"—a reference to size but also to the maker's ambitions, America's cultural aspirations of eminent domain, and the quest to preserve the Union. Artists showed large paintings—as well as sculptures—in theatrical settings and charged admission to see them.

More Neoclassical sculpture of this period is on view in The Charles Engelhard Court (700 & 701).

Peter Jay Sharp Foundation Gallery

Late Hudson River School, 1860–80

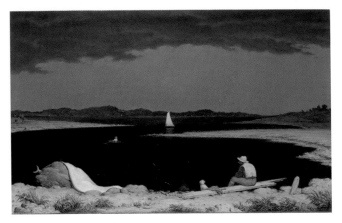

Martin Johnson Heade, *The Coming Storm*, 1859

The Joan Whitney Payson Galleries

Light became the virtual subject for many artists of the later
Hudson River School, whose work is displayed in this gallery.
Several trends in European art had an impact on American
painters, who traveled to the Old World in greater numbers than
ever before. Inspired by French Barbizon painting, George Inness
strove "to awaken an emotion" with his compositions' fragile
beauty and restrained harmonies of color. In addition, new
scientific theories involving natural law—foremost among them
Charles Darwin's *On the Origin of Species* (1859)—contributed to
the changes in landscape art. In their preoccupation with light,
these painters articulated simultaneously their interest in
naturalistic effects and their perception of the spiritual essence
of nature. They chose subjects closer to home, for an emerging
vacationing class, that expressed the country's nostalgia for the
waning wilderness. Likewise, sculptors embraced a new Realist
aesthetic, modeling distinctly American subjects whose
democratic overtones appealed to their clientele.

Thomas and Georgia Gosnell Gallery

Civil War Era, 1860–80

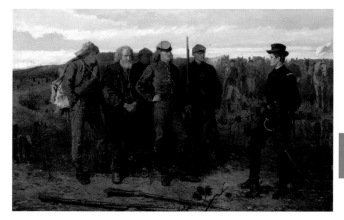

Winslow Homer, *Prisoners from the Front*, 1866

The Joan Whitney Payson Galleries

Although members of the Hudson River School such as Sanford R. Gifford painted eyewitness accounts of the Civil War (1861–65) that emphasized landscape, the war generally coincided with a resurgence in figural art. Examples of both tendencies are displayed in this gallery. In painting, the figural trend was represented most vigorously by Winslow Homer, who visited the Union front as an artist-correspondent for the popular magazine *Harper's Weekly*. After the war, Augustus Saint-Gaudens and other sculptors produced portrait busts and statues to commemorate its heroes and martyrs. Painters and sculptors alike also found subjects in the nascent liberty and continuing poverty of America's former slaves.

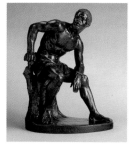

John Quincy Adams Ward, *The Freedman*, 1863; this cast, 1891

Life in America, 1860–80

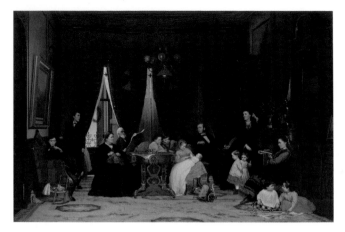

Eastman Johnson, *The Hatch Family*, 1870–71

The Joan Whitney Payson Galleries

The confluence of charged political and economic events and
profound social change during and after the Civil War created
such turmoil that many artists chose to examine only small,
reassuring slices of the human experience. Some depicted
women grappling with the new roles and responsibilities left to
them after the loss of so many men in combat. Others portrayed
children, thereby expressing a longing for prewar innocence or
embracing the commemorative atmosphere associated with the
nation's Centennial. As the agrarian basis of American life
yielded to urbanization and industrialization, artists who lived,
studied, worked, and sought patronage in cities celebrated
old-fashioned rural locales and seaside resorts as retreats from
urban existence.

In the Artist's Studio, 1865–1900

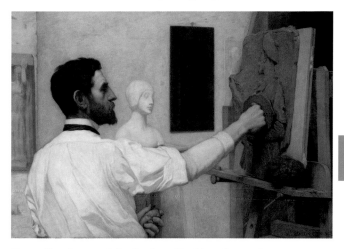

Kenyon Cox, *Augustus Saint-Gaudens*, 1887; this replica, 1908

The Joan Whitney Payson Galleries

As a glance around this gallery confirms, portrayals of artists, craftsmen, and scientists at work were popular during the late 19th century. Not only did professionalism in all lines of work burgeon, but American artists themselves became self-consciously professional, and nostalgia grew for fast-fading handicraft traditions. Underscoring the importance of the studio environment, painters of still lifes concentrated on artificial setups of manufactured objects rather than on nature's bounty, which their predecessors had described (as seen in gallery 756). The most imitated and skillful post–Civil War still-life specialist was William Michael Harnett, who painted many tabletop arrangements and pushed to its limits the art of trompe l'oeil ("trick the eye"), depicting three-dimensional objects convincingly on a two-dimensional plane.

The West, 1860–1920

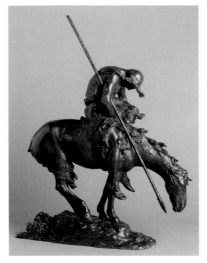

James Earle Fraser, *End of the Trail*, 1918; this cast, by 1919

The Joan Whitney Payson Galleries

Beginning in the 1820s, the American West inspired artists to explore its vast thematic potential, from the breathtaking beauty of the landscape to the gripping adventures of scouts and trappers. After the Civil War, industrialization and urbanization fueled a market for art that mythologized the vanishing frontier, while the saturation of American culture with genteel senti-mentality inspired a countervailing yearning for heroes who tested their manhood in dangerous lands. Frederic Remington and other painters and sculptors represented in this gallery celebrated cowboys and cavalrymen, who also emerged as stars of fiction, the popular press, and motion pictures. At the same time, the government's slaughter of the buffalo herds and the decimation and relocation of native peoples encouraged artists to glorify endangered animals and to commemorate American Indians as a noble, doomed race.

The Cosmopolitan Spirit, 1860–1900

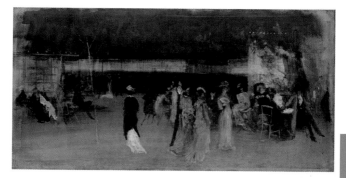

James McNeill Whistler, *Cremorne Gardens, No. 2*, 1872–77

The Joan Whitney Payson Galleries

In the late 19th century, the taste of American viewers and collectors changed in response to their expanded opportunities for travel; ready access to prints, photographs, and illustrations in magazines and journals; and familiarity with art in newly founded museums. As this audience, principally in the prosperous industrial Northeast, came to value contemporary Continental—especially French—art, American artists working in all media lived and studied abroad and investigated a wide range of subjects and styles in order to attract patronage. Operating in an increasingly professional and complex art world, they found their prospects enhanced for displaying and marketing their works on both sides of the Atlantic. Their new range, sophistication, and ambitions are apparent in this gallery.

Winslow Homer and Thomas Eakins

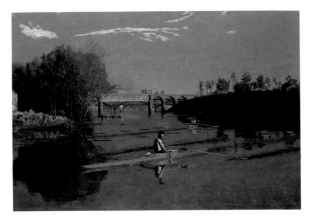

Thomas Eakins, *The Champion Single Sculls (Max Schmitt in a Single Scull)*, 1871

The Joan Whitney Payson Galleries

This gallery contains some of the most brilliant and iconic works in the history of American painting. Like the poet and journalist Walt Whitman, Winslow Homer (1836–1910) and Thomas Eakins (1844–1916) traced an arc from anecdotal accounts of American life to meditations on universal themes. Relocating in 1883 from New York City to Prouts Neck, Maine, Homer continuously observed and recorded the sea under different conditions of light and weather. After 1890, he generally abandoned narrative to concentrate on the beauty and power of the sea itself. American sculptors also celebrated New England as the nation's reassuring cultural bedrock.

Just after the Civil War, Eakins pioneered the pursuit by Americans of instruction in the art academies of Paris. He then returned to Philadelphia, where he ingeniously applied to local, modern subjects the lessons he had learned from his European contemporaries and from the old masters. Eakins's psychologically probing portraits constitute a serious exploration of American character at the turn of the 20th century.

Margaret and Raymond J. Horowitz Galleries

Images of Women, 1880–1910

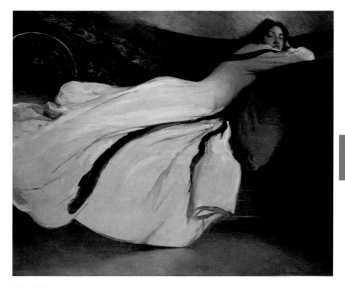

John White Alexander, *Repose*, 1895

The Joan Whitney Payson Galleries

Around 1900, refined women were favored subjects of many
American artists. The works in this gallery reflect the contem-
porary notion that a woman's proper sphere was within a
harmonious interior, absorbed in cultivated pastimes, or in a
sheltered outdoor setting, engaged in leisure activities. These
works also suggest the wide range of styles that artists enlisted
to depict their genteel subjects. Women artists were especially
successful in describing women's activities at first hand. Among
them were the painter, pastellist, and printmaker Mary Cassatt,
who settled in Paris in 1874, responded to the influence of the
French Impressionists, and became the only American to
participate in their exhibitions; and the sculptor Bessie Potter
Vonnoh, who worked principally in New York and produced
statuettes of women in conventional roles.

Richard and Maureen Chilton Gallery

American Impressionism, 1880–1920

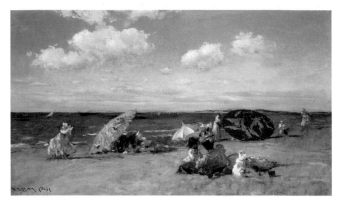

William Merritt Chase, *At the Seaside*, ca. 1892

The Joan Whitney Payson Galleries

While the expatriates Mary Cassatt and John Singer Sargent experimented with Impressionism in Paris in the late 1870s under the influence of their French counterparts, William Merritt Chase was the first artist to produce Impressionist views in the United States. His scenes of New York's public parks of the mid-1880s were inspired in part by French Impressionist works on view in American exhibitions. His light-filled canvases of the 1890s, painted at Shinnecock, New York, on the eastern end of Long Island, celebrated modern city dwellers' leisure activities in their new country retreats. Childe Hassam adopted the Impressionists' subjects and style during his student years in Paris, from 1886 to 1889. Upon his return home, he became the leading Impressionist chronicler of New York and New England.

The Frank A. Cosgrove Jr. Gallery

American Impressionism, 1880–1920

J. Alden Weir, *The Red Bridge*, 1895

The Joan Whitney Payson Galleries

Having met Claude Monet in Paris, probably in 1876, the
expatriate John Singer Sargent was inspired to experiment
with Impressionism. Throughout his successful career as a
portraitist headquartered in London (as evidenced in adjacent
gallery 771), Sargent would always refresh his studio work by
painting out of doors in both oils and watercolors. By 1887
several other American artists had been attracted to Giverny, on
the Seine about fifty miles northwest of Paris, initially by its
charm and then by the presence of Monet, who had settled in the
village in May 1883 (Sargent also called on Monet there in the
1880s). Theodore Robinson became the leader of the American
Giverny group, first visiting in 1885 and spending months
there annually from 1887 until 1892. Back in the United States,
Robinson and Childe Hassam shared their enthusiasm for
French Impressionism with their American colleagues, including
John H. Twachtman and J. Alden Weir, who became converts to
the style.

Margaret and Raymond J. Horowitz Galleries

Portraiture in the Grand Manner, 1880–1900

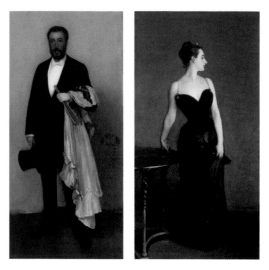

James McNeill Whistler, *Arrangement in Flesh Colour and Black: Portrait of Theodore Duret*, 1883

John Singer Sargent, *Madame X (Madame Pierre Gautreau)*, 1883–84

The Joan Whitney Payson Galleries

After the Civil War, the United States experienced profound changes, including rapid economic expansion and population growth, and emerged as a world power. Great wealth and a desire for conspicuous display characterized the period, which has been called the Gilded Age. American artists studied abroad, especially in Paris and Munich, and then competed with their European contemporaries for portrait commissions from American patrons. Both the patrons and painters were also aware of the mode of portraiture prevalent in Great Britain, which was at the apex of its imperial influence and prestige. John Singer Sargent, the quintessential American cosmopolite, was born in Italy, studied and worked in Paris, and operated thereafter with equal success in London, Boston, and New York. This gallery is a testament to the ability of Sargent and his contemporaries to capture on canvas the personalities of their intriguing acquaintances as well as their paying patrons.

Terian Family Gallery

Ashcan Painters and Their Circle, 1900–1920

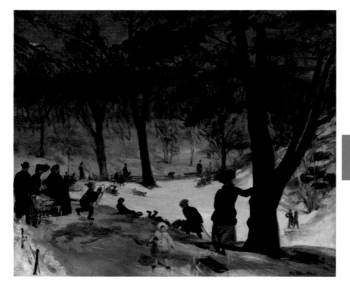

William Glackens, *Central Park, Winter*, ca. 1905

3

The Joan Whitney Payson Galleries

Beginning around 1900, a group of Realist painters advocated forthright depictions of urban life but typically took a cheerful approach to portraying urban hardships. Their leader, Robert Henri, had begun his career as a painter and teacher in Philadelphia. There, he became a mentor to George Luks, William Glackens, John Sloan, and Everett Shinn, all of whom worked as newspaper illustrators and, with Henri, moved to New York between 1896 and 1904. These artists came to be called the Ashcan School after a drawing by Henri's student George Bellows that was published in 1915. Henri and his associates showed together in several key exhibitions, including the land-mark 1908 show at New York's Macbeth Galleries of the group known as the Eight, which also included Ernest Lawson, Maurice Prendergast, and Arthur B. Davies. Works by all of the Eight are represented in this gallery.

Jan and Warren Adelson Gallery

Mezzanine

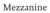

707

774

773

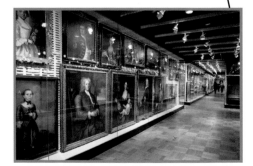

The Henry R. Luce Center for the Study of American Art

GALLERIES 773 & 774 MEZZANINE

Originally opened in 1988, The Henry R. Luce Center for the Study of American Art is the American Wing's visible-storage facility for works that are not on view in the galleries because of space limitations or other considerations. The center is completely accessible to the public, even though it is the actual working storage facility used by the American Wing's curatorial staff. Virtually the only objects that cannot be seen either here or in the galleries are those on temporary loan to other institutions, those currently undergoing conservation treatments, and light-sensitive works on paper and textiles, which can be seen by appointment.

4

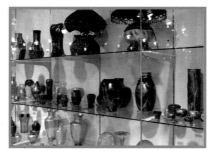

Reached from the glass elevator in The Charles Engelhard Court or via the Mezzanine Balcony, the Luce Center houses more than ten thousand works of American fine and decorative art.

Within forty-five floor-to-ceiling glass cases, objects are arranged by material or type (paintings, sculpture, furniture and woodwork, glass, ceramics, silver, and metalwork) and, within those categories, by date and form. Visible storage allows visitors to examine multiple versions of a form and to understand how it has evolved; for example, the unparalleled collection of chairs displayed in the Luce Center offers a visual history of American seating furniture from the early colonial period to Frank Lloyd Wright.

Other Luce Center highlights include the collection of more than one thousand pieces of American silver; exquisite examples of blown glass by Louis Comfort Tiffany; and a rotating selection of vintage baseball cards. Along one side of the entrance corridor are some of the center's computer stations, which contain individual in-depth records for all American Wing objects. Indeed, these digital portals can be used as a starting point for exploring what you might want to see not only in the Luce Center but throughout the American Wing. If you are interested in

American silver, a search for "silver teapot" provides images and locations for all such teapots in the collection and can be the basis for a self-directed tour. Additionally, there are areas to sit and rest in the center, with wireless connectivity throughout, so you can use your own device to access the Museum's online resources.

The Henry R. Luce Center for the Study of American Art is made possible by The Henry Luce Foundation, Inc. The Luce Center at the Metropolitan was the first of several visible-storage centers funded by the Luce Foundation.

American Tobacco Company Issue, *Honus Wagner from White Borders*, 1909–11

Donor Credits

p. 5
97.34 Gift of John Stewart Kennedy, 1897

p. 8
72.3 Gift of William Backhouse Astor, 1872

p. 9
97.19 Gift of Charles F. McKim, 1897

p. 10
19.124 Rogers Fund, 1918

p. 11
25.173 Gift of Robert W. de Forest, 1925

p. 14
Pickle stand: 1990.19 Friends of the American Wing Fund, 1990
Covered goblet: 28.52a, b Rogers Fund, 1928
Tankard: 40.184.1 Gift of Mrs. J. Insley Blair, in memory of her husband, 1940
Pair of sauceboats: 46.40.1, .2 Gift of Mr. and Mrs. Andrew Varick Stout, 1946

p. 15
Tray and urn: 2009.420.1, .2 Purchase, Sansbury-Mills Fund and Frank P. Stetz Gift, 2009
Decanter: 1995.13 Purchase, The Overbrook Foundation Gift, 1995
Sugar pot: 18.95.16 Rogers Fund, 1918
Jar: 18.95.13 Rogers Fund, 1918

p. 16
Pair of sauceboats: 59.152.1, .2 Sansbury-Mills Fund, 1959
Vase: 1992.362.2 Friends of the American Wing Fund, 1992
Bottle: 1980.502.69 Gift of Henry G. Schiff, 1980
Pitcher: 1992.230 Gift of Maude B. Feld and Samuel B. Feld, 1992

p. 17
2002.232.1 Gift of Packer Collegiate Institute Inc., 2002

p. 18
Tiffany vase: 1982.349 Purchase, Mr. and Mrs. H. O. H. Frelinghuysen Gift, 1982
Plate: 2004.94 Purchase, Barrie A. and Deedee Wigmore Foundation Gift, 2004
Washington vase: 1987.167 Purchase, Mrs. Roger Brunschwig Gift, 1987
Teapot: 97.1.1 Gift of a Friend of the Museum, 1897

p. 19
Wineglass: 1991.369 Gift of June Dorflinger Hardy, 1991
Century vase: 1987.12 Friends of the American Wing Fund, 1987
Bryant vase: 77.9a, b Gift of William Cullen Bryant, 1877
Magnolia vase: 99.2 Gift of Mrs. Winthrop Atwill, 1899

p. 20
Vase: 96.17.10 Gift of H. O. Havemeyer, 1896
Ewer and plateau: 1974.214.26a, b Gift of Mr. and Mrs. Hugh J. Grant, 1974
Coffeepot and sugar bowl: 1989.263.1a, b and 1989.263.2 Gift of Mrs. Kenneth C. Heath, in memory of Marjorie L. Sloan, and Reginald J. and Kenneth C. Heath, 1989
Covered jar: 22.186a, b Purchase, Edward C. Moore Jr. Gift, 1922

p. 21
Jamison and Rose brooch: 2000.562 Purchase, Susan and Jon Rotenstreich Gift, 2000
Necklace: 2011.18 Purchase, Barrie A. and Deedee Wigmore Foundation Gift, 2011
Marcus brooch: 2001.238 Purchase, Susan and Jon Rotenstreich Gift, 2001
Koehler brooch: 52.43.1 Gift of Mrs. Emily C. Chadbourne, 1952

p. 22
Teapot: L.2009.22.279a, b Promised
Gift of Robert A. Ellison Jr.
Revere vase: L. 2009.22.233
Promised Gift of Robert A. Ellison Jr.
Grueby vase: L.2009.22.192
Promised Gift of Robert A. Ellison Jr.
Natzler vase: L.2009.22.71 Promised
Gift of Robert A. Ellison Jr.

p. 23
67.231.1 Purchase, The Edgar J.
Kaufmann Foundation and Edward
C. Moore Jr. Gifts, 1967

p. 27
36.127 Munsey Fund, 1936

p. 28
26.290 Sage Fund, 1926

p. 31
33.110 Rogers Fund, 1933

p. 34
40.127 Purchase, The Sylmaris
Collection, Gift of George Coe
Graves, by exchange, 1940

p. 35
17.116.1–5 Rogers Fund, 1917

p. 36
16.112 Rogers Fund, 1916

p. 37
18.87.1–4 Rogers Fund, 1918

p. 40
18.101.1–4 Rogers Fund, 1918

p. 41
The installation of this gallery was
made possible through the
generosity of Donaldson, Lufkin, &
Jenrette, Inc. and Richard Hampton
Jenrette.

p. 42
2010.466 Purchase, William Cullen
Bryant Fellows Gifts, 2010

p. 43
68.137 Gift of Joe Kindig Jr., 1968
The Richmond Room was endowed
in memory of Annie Laurie Aitken.

p. 46
1972.187.1 Purchase, Emily Crane
Chadbourne Bequest, 1972

p. 47
52.184 Gift of the Senate House
Association, Kingston, N.Y., 1952

p. 48
1999.396 Purchase, Friends of the
American Wing Fund and Lila
Acheson Wallace Gift, 1999

p. 49
68.143.7 Gift of Josephine M. Fiala,
1968

p. 52
1977.1 Gift of Mrs. Hamilton Fish,
1977

p. 53
1980.76 Gift of Delaware North
Companies, Incorporated, 1980
This installation was made possible
by a gift from the Overbrook
Foundation.

p. 54
2009.226.1–26 Gift of The Museum
of the City of New York, 2008

p. 55
69.140 Gift of Kenneth O. Smith,
1969

p. 56
1992.127 Purchase, Lila Acheson
Wallace Gift, 1992

p. 57
1974.214.15a, b Gift of Mr. and Mrs.
Hugh J. Grant, 1974

p. 58
1972.60.1 Purchase, Emily Crane Chadbourne Bequest, 1972
The installation of the Frank Lloyd Wright Room was made possible through the generosity of Saul P. Steinberg and Reliance Group Holdings, Inc.

p. 62
97.29.3 Gift of Samuel P. Avery, 1897

p. 63
49.12 Gift of Bayard Verplanck, 1949

p. 64
50.228.3 Gift of Mrs. J. Insley Blair, 1950

p. 65
Bowl: 38.63 Samuel D. Lee Fund, 1938
Basket: 54.167 Morris K. Jesup Fund, 1954
Wine cup: L.2008.22 Promised Gift of Roy J. Zuckerberg
Hot-water urn: 1990.226 a–d Purchase, The Annenberg Foundation Gift, Annette de la Renta, Mr. and Mrs. Robert G. Goelet, Drue Heinz, and Henry R. Kravis Foundation Inc. Gifts, Friends of the American Wing Fund, Margaret Dewar Stearns Bequest, Mr. and Mrs. Anthony L. Geller and Herbert and Jeanine Coyne Foundation Gifts, Max H. Gluck Foundation Inc. Gift, in honor of Virginia and Leonard Marx, and Rogers, Louis V. Bell and Dodge Funds; and Gift of Elizabeth K. Rodiger, 1990

p. 66
Chest-on-chest: 2005.52 Purchase, Friends of the American Wing Fund, Mr. and Mrs. Robert G. Goelet Gift, Sansbury-Mills Fund, and Leigh Keno and The Hohmann Foundation Gifts, 2005
High chest of drawers: 18.110.4 John Stewart Kennedy Fund, 1918

p. 67
Woodwork: 28.143 Gift of Mrs. William Bayard Van Rensselaer, 1928
Wallpaper: 28.224 Gift of Howard Van Rensselaer, 1928

p. 68
97.33 Gift of Collis P. Huntington, 1897

p. 69
1993.283 Gift of Mrs. John R. Wadleigh, 1993

p. 70
1979.395 Bequest of Susan W. Tyler, 1979

p. 71
45.62.1 Bequest of Herbert L. Pratt, 1945

p. 72
62.256.2 Gift of Edgar William and Bernice Chrysler Garbisch, 1962

p. 73
33.61 Morris K. Jesup Fund, 1933

p. 74
08.228 Gift of Mrs. Russell Sage, 1908

p. 75
09.95 Bequest of Margaret E. Dows, 1909

p. 76
1975.160 Gift of Erving Wolf Foundation and Mr. and Mrs. Erving Wolf, in memory of Diane R. Wolf, 1975

p. 77
Homer: 22.207 Gift of Mrs. Frank B. Porter, 1922
Ward: 1979.394 Gift of Charles Anthony Lamb and Barea Lamb Seeley, in memory of their grandfather, Charles Rollinson Lamb, 1979

p. 78
26.97 Gift of Frederic H. Hatch, 1926

p. 79
08.130 Gift of friends of the artist, through August F. Jaccaci, 1908

p. 80
2010.73 Purchase, Friends of the American Wing Fund, Mr. and Mrs. S. Parker Gilbert Gift, Morris K. Jesup and 2004 Benefit Funds, 2010

p. 81
12.32 John Stewart Kennedy Fund, 1912

p. 82
34.92 Purchase, The Alfred N. Punnett Endowment Fund and George D. Pratt Gift, 1934

p. 83
1980.224 Anonymous Gift, 1980

p. 84
67.187.123 Bequest of Miss Adelaide Milton de Groot (1876–1967), 1967

p. 85
14.141 Gift of Mrs. John A. Rutherfurd, 1914

p. 86
Whistler: 13.20 Catharine Lorillard Wolfe Collection, Wolfe Fund, 1913
Sargent: 16.53 Arthur Hoppock Hearn Fund, 1916

p. 87
21.164 George A. Hearn Fund, 1921

p. 90
Burdick 246, T206 The Jefferson R. Burdick Collection, Gift of Jefferson R. Burdick

The texts for this guide were written by American Wing curators Morrison Heckscher, Alice Cooney Frelinghuysen, Peter M. Kenny, Elizabeth Mankin Kornhauser, Amelia Peck, Thayer Tolles, Beth Carver Wees, and H. Barbara Weinberg.

The publication was coordinated by Abbey Nova, Tiffany & Co. Foundation Curatorial Intern; and Medill Higgins Harvey, Adrienne Spinozzi, and Nicholas Vincent, Research Associates.

The plans were created by Michael Lapthorn, Senior Exhibition Designer, and were further developed for this publication by Miko McGinty.

This book is made possible by The William Cullen Bryant Fellows of the American Wing.

Text, maps, and photography © 2012 The Metropolitan Museum of Art

Compilation and design © 2012 The Metropolitan Museum of Art and Scala Publishers

Published by The Metropolitan Museum of Art, New York
Mark Polizzotti, Publisher and Editor in Chief
Gwen Roginsky, Associate Publisher and General Manager of Publications
Peter Antony, Chief Production Manager
Michael Sittenfeld, Managing Editor

In association with
Scala Publishers Limited

Cataloging-in-Publication Data is available from the Library of Congress.
ISBN: 978-1-85759-742-4

Book design by Miko McGinty
Edited by Jennifer Bernstein and Kate Norment
Typesetting by Tina Henderson
Typeset in Documenta

Printed in China
10 9 8 7 6 5 4 3 2

Photographs of works in the Metropolitan Museum's collection are by The Photograph Studio, The Metropolitan Museum of Art. New photography of the American Wing galleries is by Bruce Schwarz. Photographs on page 22 are by Robert A. Ellison Jr. Photograph on page 54 is courtesy of The Museum of the City of New York.

Front cover: Designed by Louis Comfort Tiffany and made by Tiffany Studios, *Magnolias and Irises*, ca. 1908 (detail). Anonymous Gift, in memory of Mr. and Mrs. A. B. Frank, 1981 (1981.159)
Back cover: Charles Willson Peale, *George Washington*, ca. 1780 (detail). Gift of Collis P. Huntington, 1897 (97.33)

The Metropolitan Museum of Art
1000 Fifth Avenue
New York, New York 10028
metmuseum.org

Scala Publishers Limited
Northburgh Street
10 Northburgh House
London EC1V 0AT

Distributed to the booktrade by
Antique Collectors' Club Limited
6 West 18th Street
New York, New York 10011